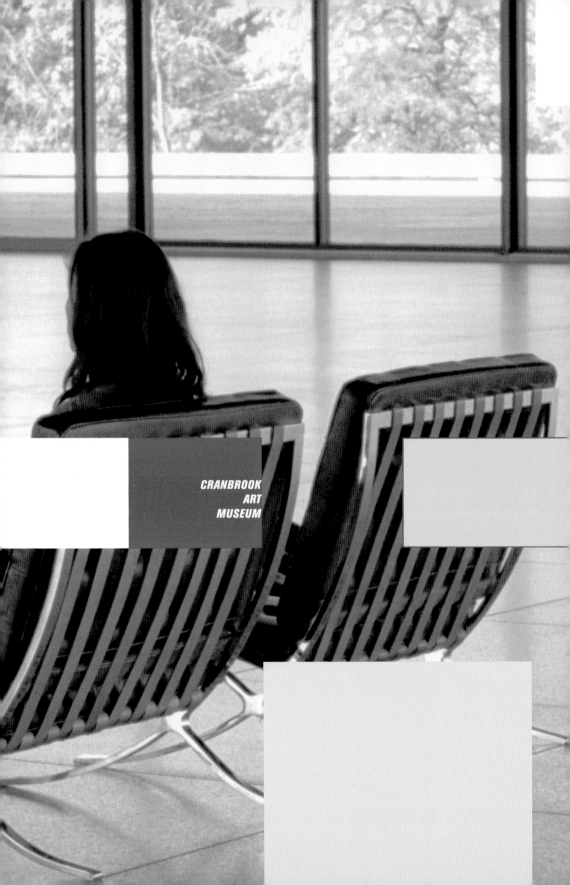

CRANBROOK
ART
MUSEUM

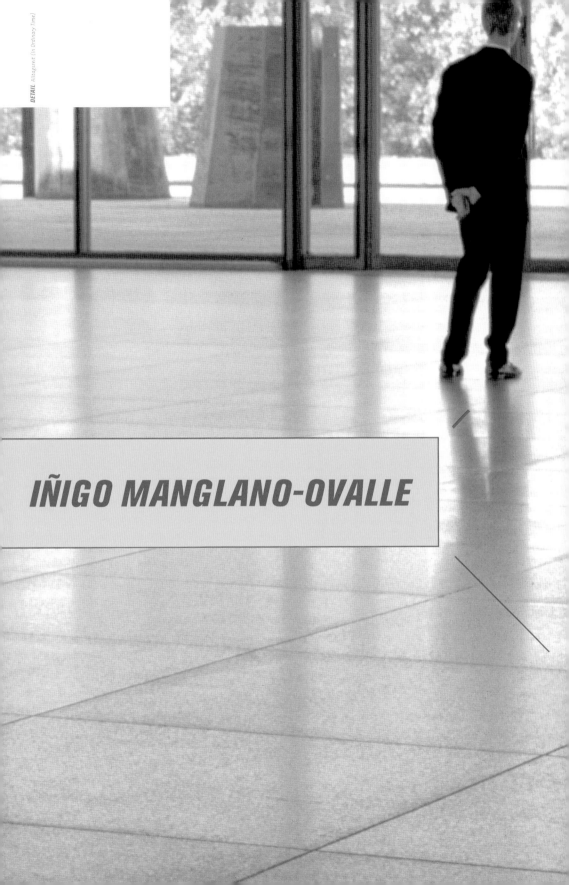

IÑIGO MANGLANO-OVALLE

IÑIGO MANGLANO-OVALLE

Cranbrook Art Museum
Bloomfield Hills, Michigan
September 16—November 25, 2001

Rose Art Museum, Brandeis University
Waltham, Massachusetts
January 24—April 7, 2002

Cleveland Center for Contemporary Art
Cleveland, Ohio
June 7—August 11, 2002

Orange Country Museum of Art
Newport Beach, California
January18—March 23, 2003

Palm Beach Institute of Contemporary Art
Lake Worth, Florida
April-June 2003

This catalogue was published in conjunction with an exhibition and tour
presented by Cranbrook Art Museum and curated by Irene Hofmann.

Editor: Dora Apel
Design and Art Direction: Kathryn Ambrose
Graphic Design: Matthew Pavlovcic
Printed in Germany by Cantz

Cover image and title page: *Alltagszeit (In Ordinary Time)*, 2001

ISBN # 0-9668577-2-0

Cranbrook Art Museum is a non-profit contemporary art museum. The Art
Museum is part of Cranbrook Educational Community, which also includes
Cranbrook's Academy of Art, Institute of Science, Schools and other affiliated
cultural and educational programs. Cranbrook Art Museum is supported in
part by its members, The Michigan Council for Arts and Cultural Affairs and the
fund-raising activities of the Serious Moonlight Steering Committee and the
Women's Committee of Cranbrook Academy of Art and Art Museum.

TABLE OF CONTENTS

FOREWORD

by Gregory Wittkopp Director, Cranbrook Art Museum

During Eliel Saarinen's tenure as both President of Cranbrook Academy of Art (1932-1946) and Director of the Department of Architecture and Urban Planning (1946-1950)—a period that roughly parallels Mies van der Rohe's tenure as Director of the Department of Architecture at the Illinois Institute of Technology (1938-1958)—he brought many celebrated architects to Cranbrook to inspire his students, including Le Corbusier, Walter Gropius and, on numerous occasions, Frank Lloyd Wright. Considering their relative proximity to each other in Detroit and Chicago, Mies van der Rohe's absence from this list is all the more prominent. While Saarinen's work at Cranbrook was considered modern by his contemporaries in the architectural community, it certainly fell outside the reductivist modernism of the International Style as espoused by Mies. Saarinen's mastery, after all, lay in his ability to synthesize historic precedents, including the medievalism of the Arts and Craft Movement, with the developing goals of twentieth-century modernism.

But if the public separation between Saarinen and Mies was great, the reality of their built work often was different. Mies's Crown Hall (1950-1956) on the I.I.T. campus and Saarinen's Cranbrook Art Museum (1938-1942)—considered by both of the architects to be among their finest works—are intimately related through the classical precedents of their temple-like forms. At the height of their careers in America, Saarinen had turned from medieval to Greek precedents while it also became clear that Mies's architecture was not a complete break with the past but rather a continuation of German nineteenth-century neoclassical traditions, replacing stone with steel and glass.

Within this architectural context, and at a time when Cranbrook has embraced a broad view of the field of architecture through new buildings on the campus by Peter Rose, Steven Holl, Tod Williams and Billie Tsien, and Rafael Moneo, we are honored to present three video works by Iñigo Manglano-Ovalle. Filmed within three of Mies's most iconic structures--the Farnsworth House in Plano, Illinois; the 860-880 Lake Shore Drive Apartment Buildings in Chicago; and the Neue Nationalgalerie in Berlin--*Le Baiser/The Kiss*, *Climate*, and *Alltagszeit* (*In Ordinary Time*) both embrace and critique the variant of modernism that Mies's buildings exemplify. While the International Style succeeded in transcending national borders, it was naïve to think that it could transcend the political hostilities and social disparities in the wake of World War I that led to its development.

At the same time, the presentation of Manglano-Ovalle's exhibition at Cranbrook demonstrates our continuing commitment to the presentation of video work. From large group exhibitions, including *Being & Time: The Emergence of Video Projection* (1997) and our recent project *Agitated Histories: Video Art and the Documentary* (2000), to individual installations by Bill Viola (1990 and 1998) and other international artists, Cranbrook has sought to engage audiences with the rich and multiple conceptual and aesthetic possibilities of this medium.

The best exhibitions result from the thoughtful collaboration of an artist and a curator, a process which requires them to clarify and focus the project's conceptual framework. Irene Hofmann, Cranbrook Art Museum's Curator of Exhibitions, began her exploration of Manglano-Ovalle's work several years ago while still based in Chicago. Initially conceived as a retrospective, this exhibition took its final form as the artist's projects related to the architecture of Mies developed and deepened. The result is a thought-provoking exhibition that reflects the talents of both Manglano-Ovalle and Hofmann, with a catalogue that is augmented by the interdisciplinary perspective of Anna Novakov, an insightful interview with the artist by Michael Rush, and the sensitive graphic design of Kathryn Ambrose.

I also would like to thank our partners in this project, the institutions and their directors and curators that are hosting this traveling exhibition: Joseph Ketner at the Rose Art Museum, Brandeis University, Massachusetts; Jill Snyder and Kristin Chambers at the Cleveland Center for Contemporary Art, Ohio; Naomi Vine and Elizabeth Armstrong at the Orange County Museum of Art, California; and Michael Rush at the Palm Beach Institute of Contemporary Art, Florida. Equally committed to their own explorations of the leading edge of contemporary art, these institutions are ideal forums for Manglano-Ovalle's dialogue with Ludwig Mies van der Rohe, a dialogue that represents the artist's explorations of the contradictions of modernism and internationalism, the ideology and politics of globalism, and contemporary issues of class and identity.

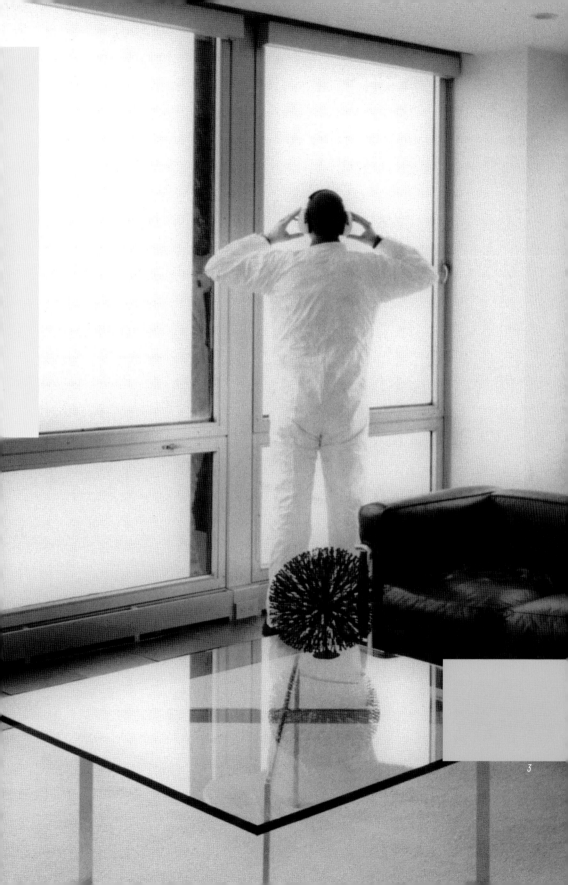

ACKNOWLEDGEMENTS

This exhibition would not have been possible without the encouragement and support of many friends and colleagues. To all who helped with this exhibition and catalogue over the last two years, I am incredibly grateful for their dedication to this project. In particular I would like to thank Gregory Wittkopp, Director of Cranbrook Art Museum, for his early enthusiasm for this project and for his continued encouragement and guidance.

Also at Cranbrook I would like to thank Roberta Frey Gilboe, Registrar, for all of her invaluable support and council during the planning, installation and tour of this exhibition. My thanks also go to Jess Kreglow, Preparator, George Doles, Assistant Preparator, and installation crew Curtis Arimia and Vincent Sansalone for their dedication to the beautiful installation of Manglano-Ovalle's work. For her friendship and support throughout this project, I would also like to thank Sarah Schleuning, Assistant Curator. My thanks also go to Vanessa Glasby, Education Assistant, and Denise Collier, Administrative Manager, for their assistance with so many details related to this exhibition.

For all of their support and collaboration on this project I would also like to thank and acknowledge Max Protetch and Josie Browne at Max Protetch Gallery. I would additionally like to thank the staff at the gallery especially David Lowe, who assisted with countless details related to the exhibition and production of this catalogue.

Thanks also go to The Bohen Foundation and the Museum of Contemporary Art in Chicago, which graciously lent works to the exhibition. Assisting with these loans were Joan Weakley and Meagan Pryor at The Bohen Foundation and Jude Palmese at the Museum of Contemporary Art.

For their stunning and inspired design for this catalogue my admiration and deep appreciation go to Kathryn Ambrose, Art Director, and Matthew Pavlovcic, Designer. My thanks also go to Anna Novakov and Michael Rush for their thoughtful contributions to this catalogue. Tremendous thanks are also due to our editor Dora Apel for her insights and great attention to every detail of this text.

Finally, it is to Iñigo Manglano-Ovalle who I owe my deepest gratitude. It has been such an enormous pleasure and privilege to work with him on this project and to spend the past few years under the spell of his remarkable and provocative works.

by Irene Hofmann Curator of Exhibitions, Cranbrook Art Museum

In the Presence of Mies: New Work by
IÑIGO MANGLANO-OVALLE

<div style="writing-mode: vertical">by Irene Hofmann</div>

Over the last decade Iñigo Manglano-Ovalle has created a diverse body of work that has scrutinized physical, social, and political boundaries between individuals, classes, and cultures. His works have challenged social arrangements, investigated global politics, and proposed new models for a more equitable and tolerant future. Engaging such varied sources as INS Green Cards, custom car stereos, firearms, radio broadcasts, and DNA samples, his works have addressed immigration and assimilation, cultural representation, urban violence, and constructions of power.

Born in Spain, raised in Bogotá, Columbia, and educated in the United States, many of Manglano-Ovalle's themes and images stem from his own shifting cultural contexts and experiences of displacement. Highly polished surfaces, spare and minimal forms, and hygienic images and objects are often the central aesthetics of his works. While this minimalist language may seem an unlikely vehicle for Manglano-Ovalle's critical explorations, his ability to infuse these reductive forms with socially and politically-conscious content contributes to the seductive tension and often unsettling nature of his richly-layered works.

In a series titled *Bloom* (1995-96), for example, Manglano-Ovalle employs the familiar rectangular forms of Minimalism to discuss some gruesome realities of crime and gun violence. These works feature a series of long steel tables, looking very much like those used in an operating room (Fig. 1). On each of the tables a block of dyed ballistic gelatin used by forensic scientists imitates the density and tensile strength of the human body. Into each of these luminous blocks of alluring yellow and orange forms, the artist has fired 45mm hollow-point bullets at close range. Because of the gelatin's relative transparency, the trajectory and terrifying force of each bullet is visible, making graphically evident the effects of a bullet specially engineered to explode and fragment as it enters a body. Such works are informed by an awareness of science and technology as mediums not only capable of being exploited for poetic ends but also as hotly-topical subjects whose ethics and methods warrant examination and critique.

<div style="writing-mode: vertical">DETAIL *Wake* from the *Bloom* series, 1995-96.</div>

Manglano-Ovalle moves beyond homage to recuperate the iconic reductive forms of Mies van der Rohe's modernist architecture as a means of examining its theoretical and practical failings and redirecting its abandoned utopian ideals to contemporary social and political concerns.

As an artist whose works represent a comingling of reductivist aesthetics and cutting-edge technology, it is not surprising that most recently Manglano-Ovalle has been drawn to the architectural works of Ludwig Mies van der Rohe (1886-1969). Considered one of the pioneers of Modernist architecture and the most influential exponent of the International Style, Mies van der Rohe's celebrated work is marked by severe simplicity and structural order and a remarkable use of technological advancements and understanding of modern materials. Mies's landmark glass and steel skyscrapers and clear-span pavilions are some of the most imitated buildings of the twentieth century. With buildings that embody the famous dictum "less is more," Mies envisioned architecture as a means of "creating order in the desperate confusion of our time."[1]

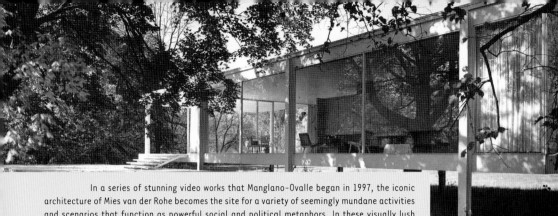

In a series of stunning video works that Manglano-Ovalle began in 1997, the iconic architecture of Mies van der Rohe becomes the site for a variety of seemingly mundane activities and scenarios that function as powerful social and political metaphors. In these visually lush works, Mies's landmark Farnsworth House in Plano, Illinois, the 860-880 Lake Shore Drive Apartment Buildings in Chicago and the Neue Nationalgalerie in Berlin serve as seductive settings and provocative subjects in Manglano-Ovalle's latest explorations of representation, social and geographic boundaries, and global politics. Like a number of his contemporaries—such as Jorge Pardo, Kevin Appel, Tobias Rehberger and Martin Boyce, whose works engage the visual vocabulary of high modernist design and architecture—Manglano-Ovalle moves beyond homage to recuperate the iconic reductive forms of Mies van der Rohe's modernist architecture as a means of examining its theoretical aspirations and practical failings, and redirecting its abandoned utopian ideals to contemporary social and political concerns.

Four new large-scale video works—*Le Baiser/The Kiss* (1999), *FM* (2000), *Climate* (2000) and *Alltagszeit (In Ordinary Time)* (2001)—represent a long-term investigation by Manglano-Ovalle of the spatial qualities, conceptual foundation, and metaphoric potential of Mies van der Rohe's architecture. Manglano-Ovalle's own ambivalent and conflicted position towards modernism is played-out in these works as they deftly negotiate the lines between homage and critique. Through each new engagement with Mies's architecture, Manglano-Ovalle explores the visual and social language of the International Style while expanding on ongoing themes that have been at the center of his social, political and aesthetic inquiry. Placing Manglano-Ovalle's new works in the context of his larger artistic program reveals some of their conceptual roots and serves to inform a reading of the often fragmented and open-ended narratives of these video works.

1. See *Mies van der Rohe's Neue Nationalgalerie in Berlin*, Gabriela Wachter, editor (Berlin: Vice Versa Verlag, 1995).

Le Baiser / The Kiss
The Contradictions of Modernism

Manglano-Ovalle's first exploration of Mies van der Rohe's architecture is through a work titled *Le Baiser/The Kiss* (1999), a video installation created from a performance staged in the Farnsworth House (1945-1951) in Plano, Illinois. A landmark glass-enclosed single-room home, the Farnsworth House is one of the clearest expressions of Mies's reductivist ideas about space and structure and one of his most notable clear-span buildings. *Le Baiser/The Kiss* features the artist as a window washer, dressed in a workman's jumpsuit and orange hat, carefully washing the house's glass entrance doors and two flanking windows (Fig. 2). Beginning with the window on the south and moving across the east façade of the house, he begins to clean the windows with soapy water and the long stokes of a squeegee (Fig. 3). The duration of the video—approximately thirteen minutes—is the time it takes the window washer to complete his task of washing the entire front glass wall of the house.

DETAIL: Le Baiser/1

A poetic homage to Mies's cool modernist space, this endless caress of the window washer's squeegee is at the same time an ironic gesture that serves literally to bring into clearer focus the practical flaws of a house made almost entirely of glass, offering no privacy for its inhabitant.

A poetic homage to Mies's cool modernist space, this endless caress of the window washer's squeegee is at the same time an ironic gesture that serves literally to bring into clearer focus the practical flaws of a house made almost entirely of glass, which offers no privacy for its inhabitant. The original resident of the house, Dr. Edith Farnsworth, was in fact perpetually distressed by the transparency and spare interior of the house and insisted that Mies provide a second bathroom in the small house so that she had someplace to hide her personal items from guests.[2]

In *Le Baiser/The Kiss*, the occupant of the house is a woman who appears framed just inside its glass doors. Standing at a portable DJ station wearing headphones, this lone female figure stands in opposition to the diligent window washer on the terrace as she conspicuously ignores the task he performs just a few feet away. As she spins records and bobs her head to the music we presume she is mixing, her gaze is focused intently on her activity, never acknowledging the window washer's endless labor.

As *Le Baiser/The Kiss*'s two disparate activities proceed, the camera shifts its focus between the DJ's creative pursuit inside the house and the window washer's attentive work on the outdoor terrace. Rather than serving to link these two opposing narratives, as the building's architect might have hoped, the immense glass exterior of the Farnsworth House here becomes an impenetrable physical and metaphoric barrier between two realms of what appears to be a rigid social hierarchy—a seemingly undisputed boundary between an affluent resident and the hired help.

Manglano-Ovalle's use of sound in this work further defines and isolates *Le Baiser/The Kiss*'s distinct social spheres. Segments shot outside the house are marked by the amplified sounds of the window washer's implements as they move across the glass panes—the intermittent squeaks of the squeegee read as slurpy "kisses" on the panes of the window. These sounds of the window washer's labor are then layered with soothing ambient sounds of the wind and rustling autumn leaves. As the camera cuts to an interior shot of the DJ inside the house, the mood shifts as the rich ethereal sounds of an electronic composition created by sound artist Jeremy Boyle fills the room.[3] Manglano-Ovalle's constructed oppositions—between inside and outside, male and female, sound and silence, transparency and opacity, homage and critique—make reference to the troubled and often contentious relationship between Mies and his wealthy female client, Edith Farnsworth, [4] while also reflecting the artist's conflicted stance towards Mies and his modernist principles.

Within the gallery installation of *Le Baiser/The Kiss*, Manglano-Ovalle's video is projected onto a large double-sided screen that is presented at the center of a suspended armature of aluminum channeling (Fig. 4). This minimalist structure references the wide-flange steel columns central to Mies's architecture, and surrounds viewers in a half-scale schematic outline of the Farnsworth House itself, moving *Le Baiser/The Kiss*'s narrative into real space and engaging the viewer's body on a phenomenological level. Suddenly the viewer is included in the scene, and invited to contemplate his/her own relationship to the social dynamics and hierarchy being played out in *Le Baiser/The Kiss*. There is never a neutral spot in this installation as viewers find themselves implicated by their own decisions about how and from where they wish to view the work.

FM
Global Politics

Two years after Manglano-Ovalle's first engagement with the Farnsworth House, he returned to Plano, Illinois, to shoot *FM* (2000). This time, Mies's domestic icon of clarity and reduction becomes an unlikely stage for a scene that evokes the Cold War era of surveillance and espionage. In *FM*, we get a better sense of the scale of the Farnsworth House and more of its interior and exterior details as Manglano-Ovalle's camera makes slow, smooth pans around the house and the surrounding grounds (Fig. 5). The vivid green foliage of the trees that frame the house serve as an intensely lush backdrop for each shot while the shadows and reflections of the leaves onto the house's immense glass exterior create *FM*'s textured foreground. The protagonists in this work are two figures who stoically appear standing in a series of shots both in and around the house. These two figures—a man and a woman dressed in white—each appear wearing a wireless headset. Nothing much occurs in *FM* as these figures gaze off into the distance, focusing intently on the information coming through on their headsets; there is an overwhelming sense that they, like we, are waiting for something to happen. Manglano-Ovalle's figures appear vigilant and attentive as if the Farnsworth House has become a kind of clandestine surveillance headquarters. This reading is further supported by the enigmatic soundtrack to *FM*, which features a combination of electronic static and a series of numbers being recited in various foreign languages. The label for this work reveals that the source of this transmission being sent to *FM*'s two figures is a series of encoded Soviet bloc and NATO radio broadcasts from the 1970s. *FM* now propels us into the heightened anxiety of Cold War politics and a scenario that alludes to present-day narratives of global espionage, military reconnaissance and Big Brother voyeurism.

DETAIL: Le Baiser/The Kiss

 The use of radio transmissions and the exploration of global surveillance and inter-national relations are themes Manglano-Ovalle addresses further in a recent work titled *Search (En Busquedad)* (2000), a site-specific installation commissioned by "inSITE," a bi-national organization that hosts public art projects along the San Diego-Tijuana border. *Search* was installed in a bullring at Playas de Tijuana, approximately 100 feet away from the United States border (Fig. 6). Covering the arena of this 40-year-old bullring were massive stark white canvas tarps that created a large parabolic dish. With a receiver installed in the center of the tarps and a radio antenna suspended in the air above the ring, Manglano-Ovalle transformed the bullring into a low-tech radio telescope that broadcasted signals from the sky above Tijuana to speakers inside the bullring (Fig. 7). The telescope's broadcast could also be heard on FM pirate radio stations that could be picked up in the surrounding area. In an ironic gesture, Manglano-Ovalle's intervention into the Tijuana bullring referenced surveillance and monitoring equipment used by the United States at the border with Mexico, but instead of searching for "illegal aliens," Manglano-Ovalle's device was searching for aliens in the sky. With *Search*, Manglano-Ovalle created both a pristine Minimalist form and phenomenological experience while commenting on the contentious politics and divisive issues of this highly-charged border region.

2. See Alice T. Friedman, *Women and the Making of the Modern House: A Social and Architectural History* (New York: Harry N. Abrams, Inc, Publishers, 1998.)

3. This composition by Boyle, itself titled *Kiss*, is a techno-composition of sampled and manipulated sounds whose original source is a short guitar solo from the band KISS, originally recorded in the 1970s.

4. Through all of their very public dis-putes over the building's cost, spare design, materials etc., Mies ultimately retained creative control over the archi-tecture, while Dr. Farnsworth was able to insert her voice into the interior by refus-ing Mies's reductive furniture for the house and decorating it with her own antiques and personal items. See Friedman.

Climate
Weather as a Metaphor

Global politics continues as a potent theme for Manglano-Ovalle in his multi-channel installation *Climate (2000)*. Here, Mies's iconic twin apartment highrises at 860-880 Lake Shore Drive in Chicago are the site for a series of ominous images and seemingly disconnected narratives. In this work, scenes were shot in the lobby and in one of the apartment units of these spectacular steel-framed glass-wall buildings fronting Lake Michigan. Icy and futuristic images in this nonlinear narrative set up an examination of global climates and borders and the control of the world's economic markets. Here the weather, an entity that neither recognizes borders nor ideologies, becomes a compelling metaphor for future social, global and economic arrangements. With *Climate*, Manglano-Ovalle calls into question the promise and ideology of Mies's modernist architecture as a social engineering project, which, in spite of its failure in its own time, now becomes the ideal model for contemporary aspirations of universalism, globalism and efficiency.

As in *Le Baiser/The Kiss*, *Climate*'s video images are presented on double-sided wide format screens that are articulated by a structure of suspended aluminum framework (Fig. 8). Here, the aluminum channeling serves to define three perpendicular viewing spaces, making visual reference to the distinctive steel window mullions and door frames that define the 860-880 apartment buildings while emphasizing the isolated and fractured nature of *Climate*'s narratives. One of *Climate*'s three central scenes features images of official looking traffickers of some kind wearing headsets and attending to the skies outside the windows of one of the upper floor apartments (Figs. 9 and 10). An anemometer (a devise used to determine the speed and direction of the wind) in the front of the large windows suggests that this particular apartment has perhaps been commandeered as a makeshift surveillance site and weather station. With an unflinching calm and severity, the two weather-watching figures set a sinister tone as they stare out across a vista of cloudy skies listening intently to the incoming information on their headsets.

These scenes then interchange with another menacing activity in the apartment: a close-up view of the meticulous dismantling and cleaning of a machine gun (Fig. 11). Although the face of this gun aficionado remains off camera, his skill in handling this semiautomatic weapon is evident as his steady hands methodically unload, dismantle, clean and then reassemble its parts. The reflective glass tabletop he works on and the empty gray sky that serves as a backdrop for this scene further contribute to its threatening mood.

In the lobby of the building, the third of *Climate*'s narratives is revealed with shots of a nervous woman seated on a chair (Fig. 12). Visibly uncomfortable and anxious, she sits in the lobby waiting and watching while a nearby security guard sits behind a bank of security monitors and watches the activities in the building's public spaces. As with *Climate*'s other two scenarios, there is no dramatic activity here, only a sense of waiting and preparation for some impending and perhaps dangerous event. *Climate*, it seems, not only refers here to weather systems but also to the atmosphere of Manglano-Ovalle's scenes, which are permeated by an ominous mood and an environment of isolation.

Climate's complex soundtrack of official sounding voiceovers, whispers, lullabies and a new score by Jeremy Boyle, adds another layer to these enigmatic narratives. A lullaby sung by a female voice accompanies views of the nervous woman in the lobby—an allusion to her role as a surrogate mother—while interspersed whispered passages deliver a kind of free verse poetry: "It has come to the point where you wish you had felt it yourself—the weather shifts, traceable patterns. Through each of these gaps, we sustain the visible. It will run its course—with the loveliest being the space between."

A weather report of sorts being broadcast in Korean accompanies images of the two surveillance figures. A translation of this report reveals a futuristic moment when the world's political and geographic borders have just ceased to exist and where the globe's climactic changes determine the fluctuations in economic markets. This particular report calls for a shift in the gulf-stream that will cause the water temperature of the North Atlantic to rise, which will in turn create favorable conditions for upstart software companies based in what was known as Indonesia. The report continues to predict that these changes in the region's standard of living will effect precipitation over the land once called Australia.

It now becomes evident that *Climate*'s stoic weather-watchers are doing more than just collecting meteorological data but that they are in a position of tremendous and potentially dangerous power in an ominous vision of globalization. These weather-watchers or economic-climatologists, as Manglano-Ovalle calls them, stand guard at a time of "synchronized global access" in the "new state of world transparency." Manglano-Ovalle writes: "The era of new transparency would level the playing field, right injustice, erase difference, all the while increasing everyone's happiness and well being."[5] We are looking in on a quasi-utopic world where Chaos theory reigns, borders have dissolved and where the word "foreign" has no meaning. "Everything for everybody and at all the same time," declares *Climate*'s lofty mantra of simultaneous opportunity.

DETAIL: Climate.

We are looking in on a quasi-utopic world where Chaos theory reigns, borders have dissolved and where the word "foreign" has no meaning.

The link between the weather and the world's global markets as explored in *Climate* is also suggested in an earlier installation by Manglano-Ovalle titled *The El Niño Effect* (1997) where climatic occurrences also become a construct for political metaphors. In this work Manglano-Ovalle involved viewers in an intimate sensory experience and a poetic exploration of borders.[6] At the center of this installation were two shiny white sensory deprivation flotation tanks in which audience members were invited to submerge themselves during 90-minute sessions (Fig. 13). Asked to participate in pairs, visitors to the installation were first directed to the rear of the gallery where they were asked to disrobe and shower in private showers (Figs. 14 and 15). After leaving the showers and changing stalls, participants then climbed into the saline tanks for a 90-minute submergence.[7] Once inside the tanks' womb-like environments, participants were likely to experience a state of meditative self-awareness and a mixture of claustrophobia and deep relaxation. This interactive component of *The El Niño Effect* not only encouraged an intimate engagement with the work, but also was in keeping with Manglano-Ovalle's interest in inserting what he calls a "public service" element in his work—in this case, a free luxury spa experience that heightened sensorial awareness.[8]

For audience members who merely wished to observe the installation, *The El Niño Effect*'s large white submersion tanks recalled the Minimalist forms of Robert Morris and shiny surfaces of Donald Judd, while the sterile white showers, changing rooms and gallery walls created a hygienic, almost spa-like atmosphere. Two small video monitors in the gallery introduced the only bit of color into the stark installation with *Windshear*, a meditative video piece featuring a continuous time-lapse loop of images of rapidly-moving clouds above the US/Mexico border at Nogales, Arizona (Fig. 16). The formation and movement of these particular clouds indicated a cataclysmic wind-shear taking place—a prophetic sign of an impending storm and a fitting allusion to the highly charged nature of this particular border site. A soothing new age soundtrack of what sounds like a rainstorm accompanies the video, filling the gallery with a relaxing cadence. This calming sound piece by Manglano-Ovalle, titled *Sonambulo*, makes reference to the artist's earlier concerns with urban violence, as this sound is actually the digitized and manipulated sound of a single gunshot that the artist recorded in his Chicago neighborhood.

11

The title of this multisensory installation further places its meaning within a global context. A worldwide climatic phenomenon, El Niño (a name given to this occurrence by the Spanish Conquistadors that means "the child of God") refers to times when the ocean temperatures off the eastern coast of South America are unusually warm. While this phenomenon typically disappears after a few months, every few years it occurs on a large scale and remains for a long period, often with dramatic effects on climates and economies worldwide. An El Niño during the 1970s, for example, caused the international price of soybeans to rise while the 1982-83 El Niño triggered catastrophic global climatic changes that caused the deaths of an estimated 2,000 people. As a phenomenon with global implications that, like the wind-blown clouds on Manglano-Ovalle's monitors, recognizes neither political nor physical borders, El Niño becomes a powerful metaphor for a borderless future. As a Spanish term linked with nuisance and upheaval, the name El Niño also becomes a subversive symbol of the Latin "other" and irrational fears of menacing and uncontrollable border crossings from the south.[9]

SAD Light Room (1999) continued Manglano-Ovalle's interests in climatic occurrences and therapeutic participatory elements in his installations and prefigures his work with Mies van der Rohe. In this work, pairs of visitors were invited to a free session of light therapy as they reclined on two white leather Mies van der Rohe-designed chaise lounges (Fig. 17). Laying back on these twin lounges—looking very much like spa beds or unusually low massage tables—visitors are bathed in light specially created to cure the depressive effects of Seasonal Affective Disorder, a condition common in parts of the world that do not receive enough natural sunlight during the winter months. The hygienic atmosphere created by Manglano-Ovalle's sterile white gallery is interrupted only by the sounds of white noise introduced in this work to complicate the ostensibly serene environment of this installation.[10]

Alltagszeit (In Ordinary Time)
Individual Identiy and the Portrait

In the fall of 2000 Manglano-Ovalle turned his camera to Mies van der Rohe's last great building for the creation of *Alltagszeit (In Ordinary Time)*. In this new video work, Mies's Neue Nationalgalerie in Berlin becomes the breathtaking backdrop for an elegant choreography of portraits staged in the building's magnificent glass-walled entrance hall. A monumental clear-span building, the Neue Nationalgalerie is marked by a massive square roof structure poised on eight perimeter steel support columns. Designed and built between 1962 and 1968, the austere Neue Nationalgalerie is perhaps one of Mies's most classical buildings and is the realization of his concept of a universal architectural space—a space that both fulfills the client's needs and allows for individual freedom of organization within that space.[11] Built to house a collection of twentieth-century art, the Neue Nationalgalerie is situated in Berlin's cultural center at Kemperplatz, a site that also includes the seventeenth-century St. Matthew's Church, the Museum of Applied Arts, the Chamber Music Hall and the Berlin Philharmonic.

Shot in 35mm film and transferred to video, Manglano-Ovalle's *Alltagszeit* features manipulated footage from a twelve-hour performance shot from daylight to dusk in the museum's huge glass central hall (Fig. 18). During this day-long performance, figures walk in and out of the entrance hall space. Some enter from the left, others from the right (Fig. 21). Some enter in groups and stand still in the space for a period of time, while others enter alone and seat themselves on one of the Mies van der Rohe-designed Barcelona chairs that populate the hall. Segments shot in the morning are marked by a glorious and vibrant sunrise streaming through the windows, while the afternoon shots are framed by the rich green foliage of the trees outside and the elegant form of the nearby St. Matthew's Church (Fig. 20). As dusk approaches, shadows grow dark and long on the building's granite floor while sunlight low on the horizon pierces through the windows a final moment before the hall is filled with darkness.

Manglano-Ovalle's initial conceptual inspiration for *Alltagszeit* came from Jacques Tati's 1967 film *Play Time,* an epic of the modern world in which the film's protagonist gets lost in a maze of modern architecture. A design-collage of the Neue Nationalgalerie by Mies that features a figure standing in the building's glass-fronted main hall further defined how Manglano-Ovalle would use Mies's space and how its reductive and expansive qualities have the effect of investing the inhabitants of the building with a grand importance.

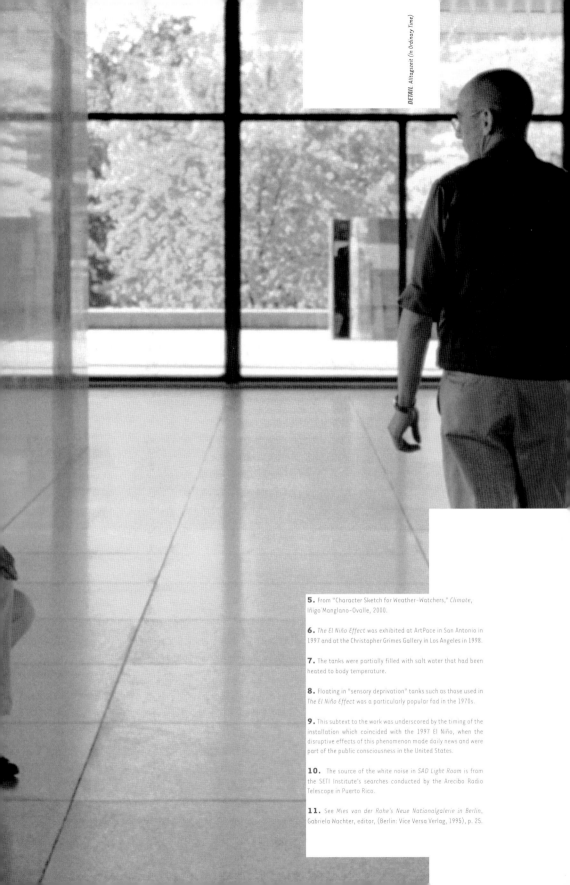

5. From "Character Sketch for Weather-Watchers," *Climate*, Iñigo Manglano-Ovalle, 2000.

6. *The El Niño Effect* was exhibited at ArtPace in San Antonio in 1997 and at the Christopher Grimes Gallery in Los Angeles in 1998.

7. The tanks were partially filled with salt water that had been heated to body temperature.

8. Floating in "sensory deprivation" tanks such as those used in *The El Niño Effect* was a particularly popular fad in the 1970s.

9. This subtext to the work was underscored by the timing of the installation which coincided with the 1997 El Niño, when the disruptive effects of this phenomenon made daily news and were part of the public consciousness in the United States.

10. The source of the white noise in *SAD Light Room* is from the SETI Institute's searches conducted by the Arecibo Radio Telescope in Puerto Rico.

11. See Mies van der Rohe's *Neue Nationalgalerie in Berlin*, Gabriela Wachter, editor, (Berlin: Vice Versa Verlag, 1995), p. 25.

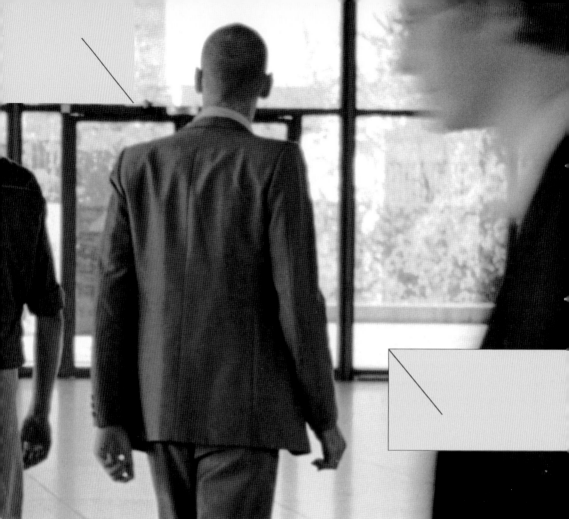

In the final cut of *Alltagszeit*, the hours of footage that were created during the performance have been condensed into a mesmerizing dance of light and movement. Using a combination of time-lapsed and real time segments, in a matter of about sixteen minutes we see the entire day and all of its activities elapse. Set to a hypnotic newly composed Jeremy Boyle soundtrack, *Alltagszeit* is marked by the recurring appearance of individual video portraits of Manglano-Ovalle's performers who appear full-screen and for only seconds at a time (Figs. 19 and 22). Of all the figures who pass through the hall during the day, one male figure emerges as the focus of this choreography; in fact, all movements seem to be in relation to him. Appearing alone in the hall at both daylight and dusk and at moments throughout the day, he becomes *Alltagszeit*'s heroic protagonist in a narrative that becomes a poetic allegory for one man's life. In contrast to *Le Baiser/The Kiss*'s ironic homage and *Climate*'s images of isolation, *Alltagszeit* has an emotional, almost spiritual tone. With a title that references the Catholic Mass calendar and prominent views of St. Matthews' Church, *Alltagszeit* underscores Mies's own desire that this architecture become the new church, the new temple and a timeless and universal stage for the individual.

The riveting series of brief video portraits that recur throughout *Alltagszeit* are some of this work's most gripping images in their directness and individuality. They relate to a number of Manglano-Ovalle's earlier works that explore identity and representation. In *Assigned Identities* (1990), for example, Manglano-Ovalle addressed the photographic images of immigrants that are used for identifying individuals on a United States "green card." In a series of works that resemble these ID cards, the artist presented individual portraits without any additional identifying information as a means of undermining the identification categories and often dehumanizing classificatory procedures of the U.S. Immigration and Naturalization Services.**12** Since the artist's subjects for these works actually were individuals seeking amnesty from the INS, this project also served to guide participants through the bureaucracy of the application process.

14

Later, in *Street Level Video* (1992-93), video portraits of and by former Chicago gang members from the artist's predominantly Latino West Town neighborhood became a central feature of this significant community-based project that sought to explore the real and artificial borders between cultures and neighborhoods. This long-term video collaboration featured interviews with residents conducted by the youths that began a dialogue about identity, territory and gentrification, which ultimately became part of several installations, including a West Town block party, that fostered a greater understanding of Latino youth and neighborhoods.

A more abstract form of portraiture became the center of *The Garden of Delights* (1998), an installation that recalled the reductive forms of color field painting through a series of rich chromatic digital DNA portraits (Fig. 23 and 24). By making visible an individual's DNA "fingerprint," this project examined the changing nature of the portrayal of individual representation, raising questions about the ethics and cultural ramifications of the new scientific technology that made these images possible. *The Garden of Delights* is comprised of a suite of forty-eight life-sized Cibachrome prints representing the DNA of individuals from around the world. To create these portraits, Manglano-Ovalle invited sixteen people to participate, each in turn choosing two additional people with whom they wished to form a triptych. A genetics laboratory then analyzed DNA samples collected from each participant and created a computer-generated image of a segment of each individual's DNA "fingerprint." With colors chosen by the participants, each portrait was then output as a human-scale digital photograph and labeled with the individual's first name.

> *. . . Mies's iconic spaces become invested with evocative new meanings, revealing themselves to be the universal and socially-engaged sites Mies always hoped they could be.*

Experienced as a room-sized installation, *The Garden of Delights*-titled after Hieronymus Bosch's similarly named triptych of morality and perversion in the Middle Ages—becomes a vibrant field of abstraction that, like Bosch's visions of excess, is as seductive as it is sinister. These portraits raise alarming questions about the use/misuse of this new scientific means of identification and what role it will play in future classifications of identity. At the same time, *The Garden of Delights* provides an opportunity to reassess stereotypical constructions of identification and to consider how an individual's biological identity might impact our understanding of more visible surface traits such as "race" and ethnicity.[13]

Today, almost three years after his first engagement with Mies van der Rohe, Manglano-Ovalle has begun to look beyond the great architect. His intimate interaction with Mies's landmark buildings over the past several years has produced a seductive and provocative body of video works that conduct an ongoing discourse about the ideals, failures and contradictions of Modernism and an exquisite tension between homage and critique. As subjects in Manglano-Ovalle's ongoing political observations and social criticisms, Mies's iconic spaces become invested with evocative new meanings, revealing themselves to be the universal and socially-engaged sites Mies always hoped they could be.

12. Specific parts of an immigrant's physiognomy such as the ears are documented and measured for the purposes of identification.

13. Beyond these contemporary social and ethical debates surrounding identity, *The Garden of Delights* has significant parallels to an eighteenth-century practice of racial categorization known as casta paintings. Common in Spain's New World colonies, the casta paintings illustrated the result of the intermingling of the three major races that inhabited Spain's colonies in the Americas: Indians, Spaniards, and Africans. Typically in these paintings a man and a woman of varying ethnicities are portrayed with their child-titles such as Espanol con India sale Mulato (Spaniard with Black makes Mulatto) identified and assigned a name to the new "racial mix." This taxonomy of ethnic hybrids was intended to portray a society that was an ordered and hierarchical one, despite its racially mixed population. With the Spaniard at the top of the racial and socio-economic caste system, sixteen casta categories were usually identified as a means of defining and ultimately exerting control over colonial society. These unsettling paintings reveal a Spanish culture obsessed with "racial purity" and with fabricating an artificial racial hierarchy. Dismantling the Spanish casta model, *The Garden of Delights*'s sixteen triptychs of individual DNA portraits moves beyond skin color and race as a means of identification to what Manglano-Ovalle characterizes as a "non-hierarchical spectrum of ethnicity."

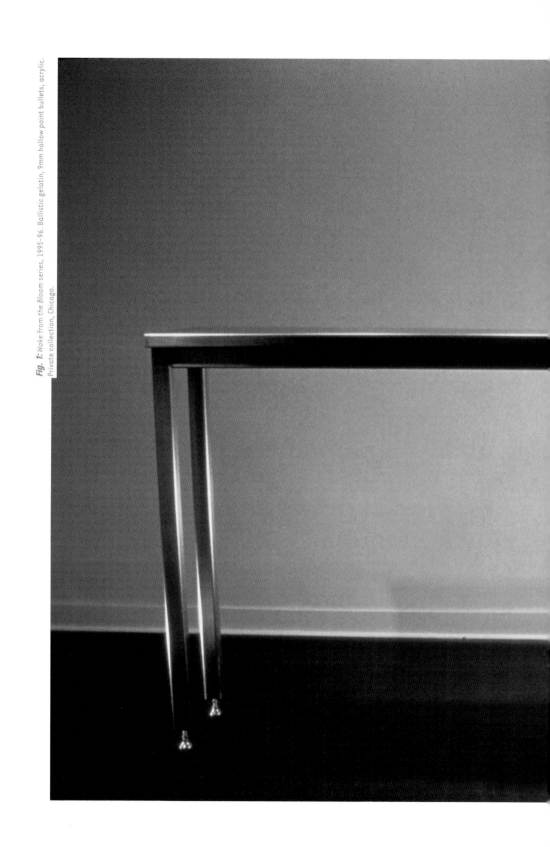

Fig. 1: *Wake* from the *Bloom* series, 1995–96. Ballistic gelatin, 9mm hollow point bullets, acrylic. Private collection, Chicago.

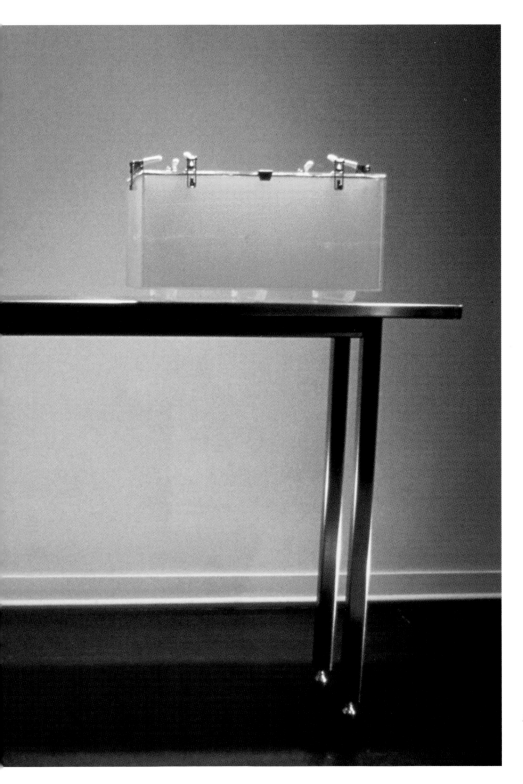

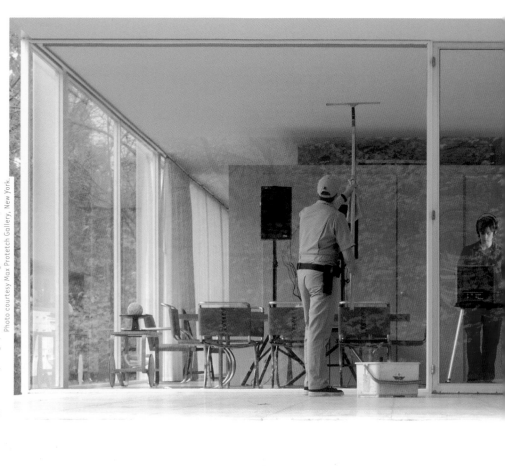

Fig. 2: *Homage* (from *Le Baiser/The Kiss*), 1999. Color photograph laminated to Plexiglas. Edition of 8, 29" x 63." Photo courtesy Max Protetch Gallery, New York.

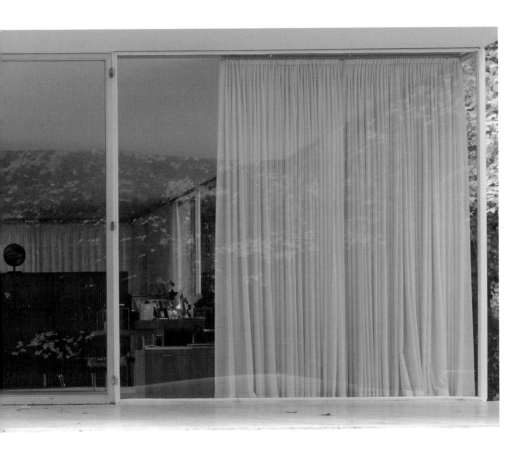

Detail: from *Le Baiser/The Kiss*, 1999. Suspended aluminum framework, video projection with sound, dimensions variable. Photo courtesy Max Protetch Gallery, New York.

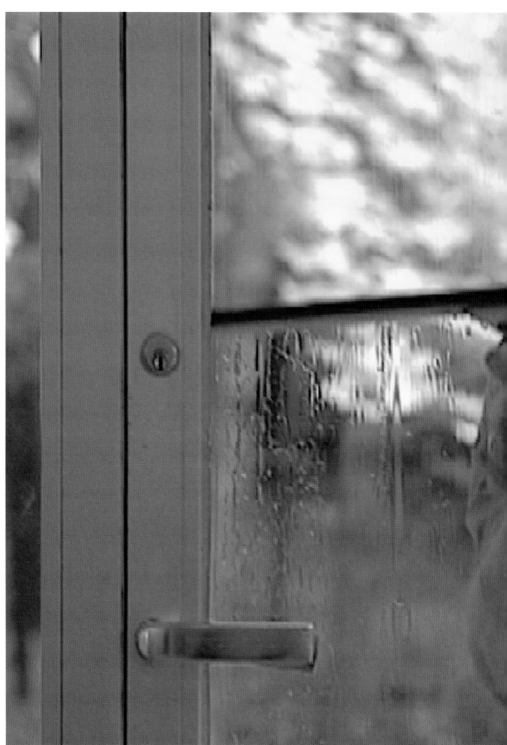

Fig. 3: Still from *Le Baiser/The Kiss*, 1999. Suspended aluminum framework, video projection with sound, dimensions variable.
Collection Museum of Contemporary Art, Chicago, Sara Lee Corporation Purchase Fund. Photo courtesy Max Protetch Gallery, New York.

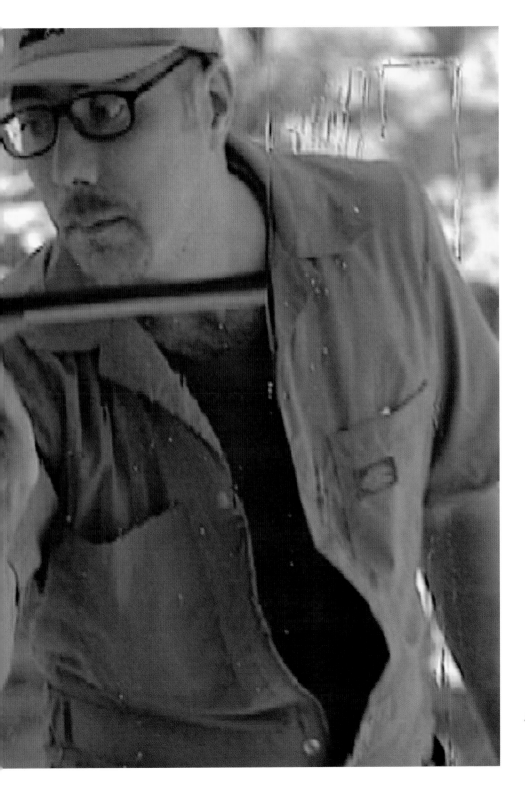

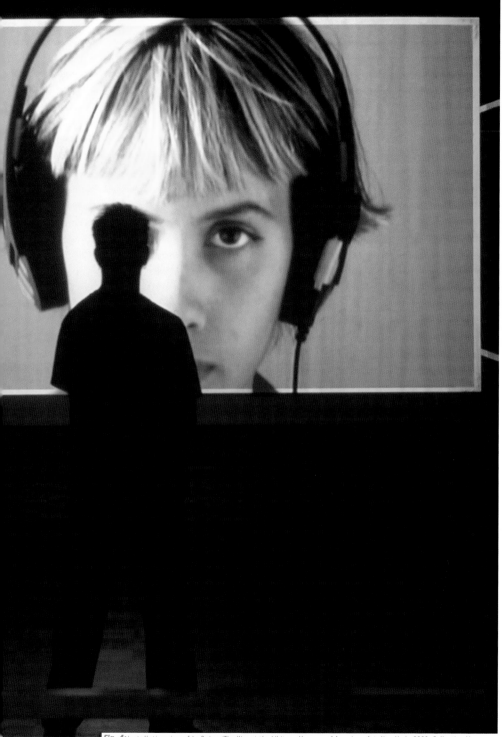

Fig. 4: Installation view of *Le Baiser/The Kiss* at the Whitney Museum of American Art, New York, 2000. Collection Museum of Contemporary Art, Chicago, Sara Lee Corporation Purchase Fund. Photo by Dennis Cowley. Courtesy Max Protetch Gallery, New York.

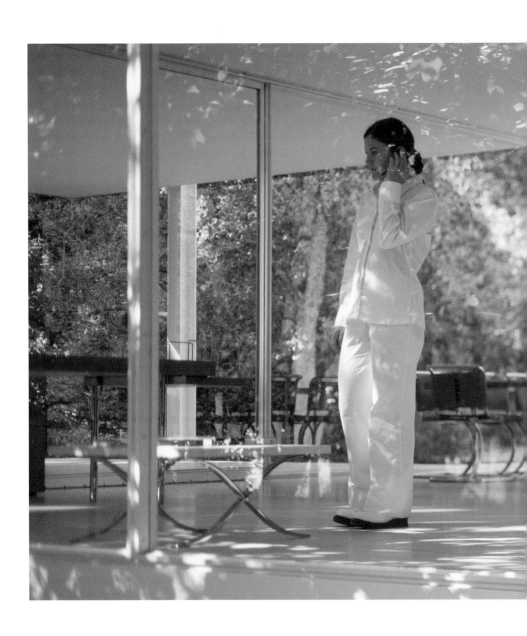

Fig. 5: *Selena II* (from *FM*), 2000. Color photograph laminated to Plexiglas. Edition of 10, 30" X 52". Photo courtesy Max Protetch Gallery, New York.

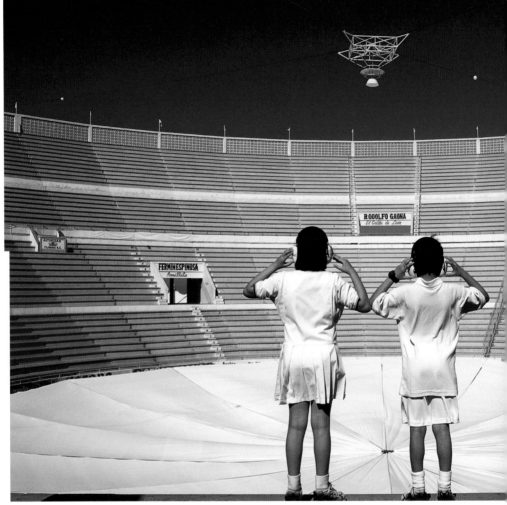

Fig. 6: Search (*En Busquedad*), 2001. Radio telescope installation at the Plaza Monumental Bullfight Ring, Tijuana, Mexico. Photo by Alfredo De Stefano.

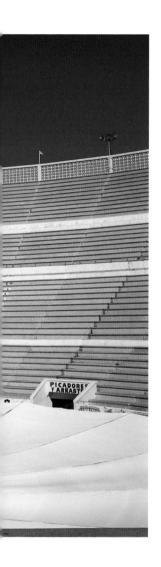

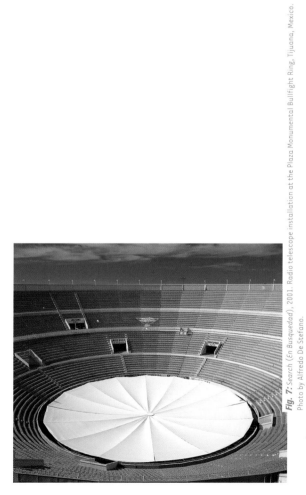

Fig. 7: Search (*En Busquedad*), 2001. Radio telescope installation at the Plaza Monumental Bullfight Ring, Tijuana, Mexico. Photo by Alfredo De Stefano.

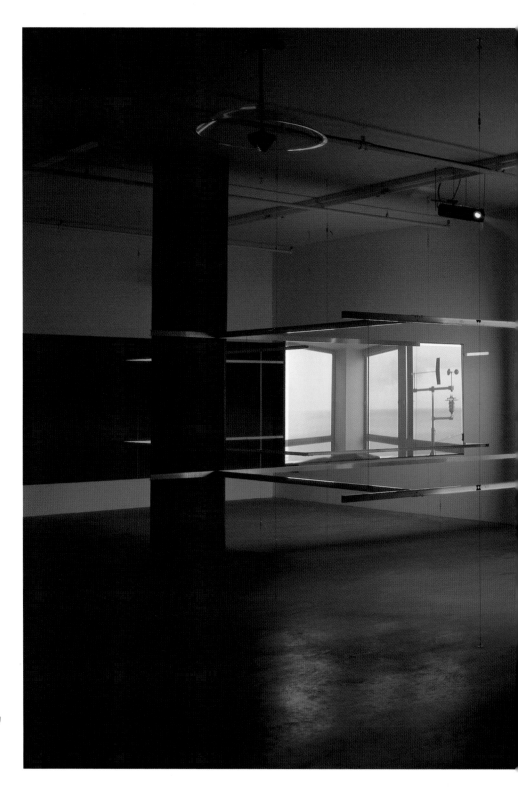

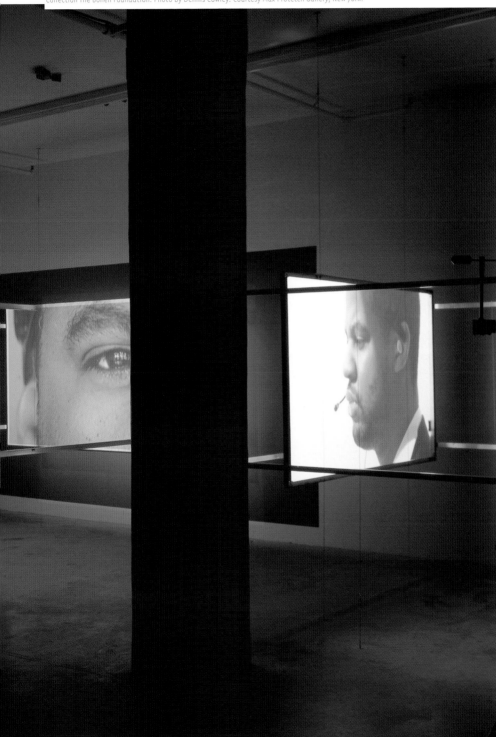

Fig. 8: Installation view of *Climate*, 2000. Suspended aluminum framework, multichannel video projections with sound, dimensions variable. Collection The Bohen Foundation. Photo by Dennis Cowley. Courtesy Max Protetch Gallery, New York.

It has come to the point where you wish you had felt it yourself—the weather shifts, traceable patterns. Through each of these gaps, we sustain the visible. It will run

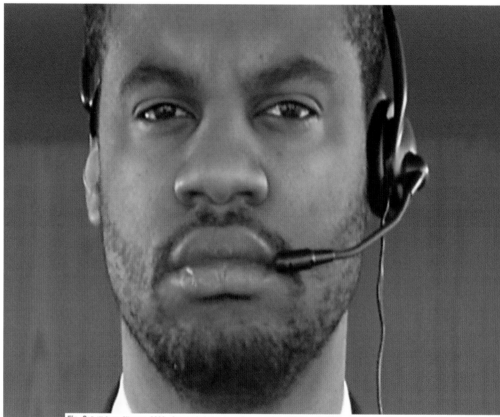

Fig. 9: Still from *Climate*, 2000. Suspended aluminum framework, multichannel video projections with sound, dimensions variable. Collection The Bohen Foundation. Photo courtesy Max Protetch Gallery, New York.

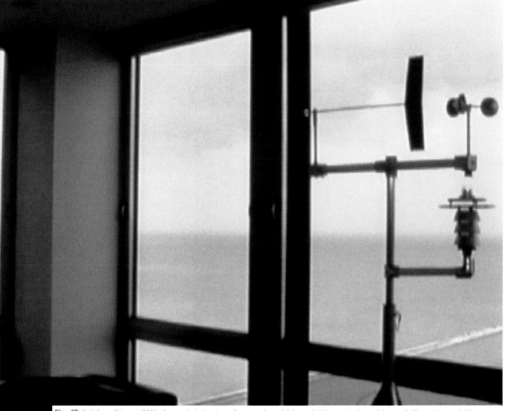

Fig. 10: Still from *Climate*, 2000. Suspended aluminum framework, multichannel video projections with sound, dimensions variable. Collection The Bohen Foundation. Photo courtesy Max Protetch Gallery, New York.

its course—with the loveliest space being the space between. It's unclear, for example, whether anyone understands that this beautiful space is a model for that beautiful place. Whether it is a good idea,

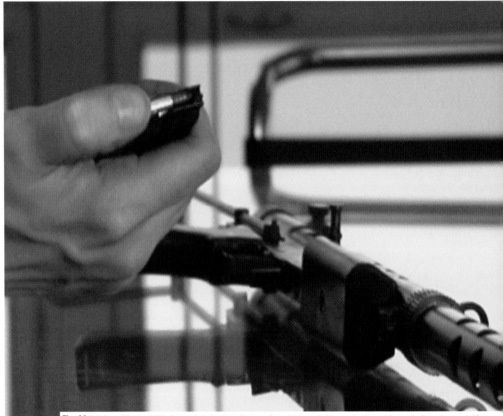

Fig. 11: Still from *Climate*, 2000. Suspended aluminum framework, multichannel video projections with sound, dimensions variable. Collection The Bohen Foundation. Photo courtesy Max Protetch Gallery, New York.

From Climate soundtrack. Text by Jane M. Saks in collaboration with Iñigo Manglano-Ovalle.

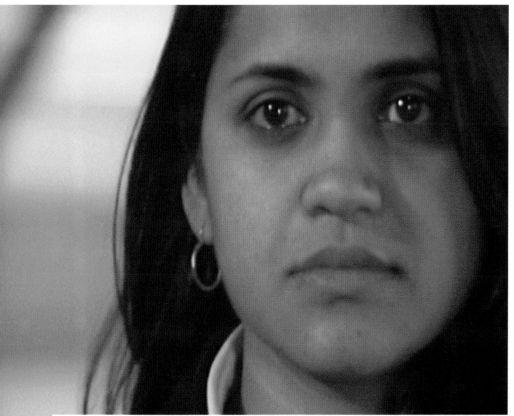

Fig. 12: Still from Climate, 2000. Suspended aluminum framework, multichannel video projections with sound, dimensions variable. Collection The Bohen Foundation. Photo courtesy Max Protetch Gallery, New York.

The world's borders had ceased to exist, they had announced it on the network news a week ago. He was listening to a (corporate) broadcast about the new global climate in a language he didn't understand, in a country that no longer existed, from a nation that had ceased to be. He tuned his short band radio to a station that broadcasted from the other side of the world without (with no) borders, a world opened for free transmission, free exchange, freedom of movement, freedom from allegiance, the new state of world transparency... Through his right ear he was strained to hear nothing, through his left ear he attempted to give in to the sounds that were once considered foreign. "Foreign" a concept that had lost much of its value in the last week. He was one of a new breed of Eco-eco analysts, or economic- climatologists, or "weather watchers" as they called themselves. His or "skyscrapers" as some would call them, job was to analyze global shifts in weather (climate) and create statistical models that would inform (market) trading in futures. They were broadcasting today's reports for next month's predictions on the futures market and the rainfall in the Amazon basin. He had compiled those figures yesterday and had submitted them to the bureau this morning. Now half of him listened to them in a language he didn't understand, while the other half struggled to embrace (the) silence.

From "Character Sketch for Weather-Watchers," Climate, Iñigo Manglano-Ovalle, 2000.

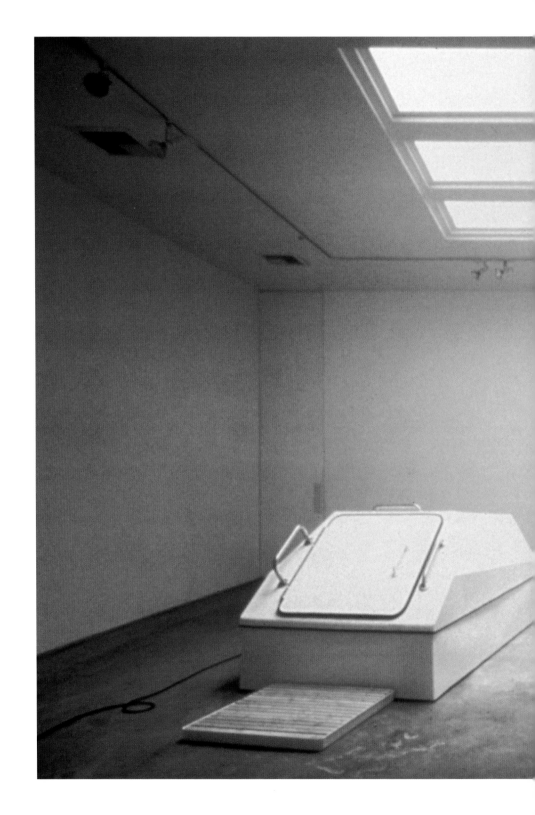

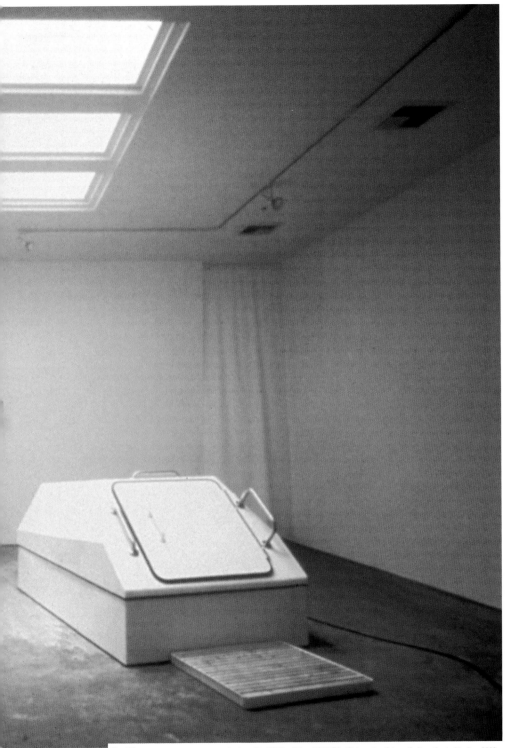

37

Fig. 13: Installation view of twin tanks from *The El Niño Effect*, 1997/98. Christopher Grimes Gallery, Santa Monica, 1998.

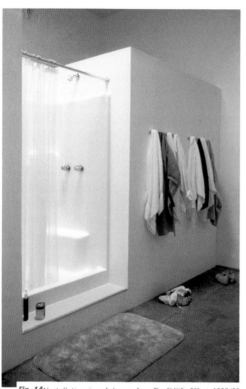

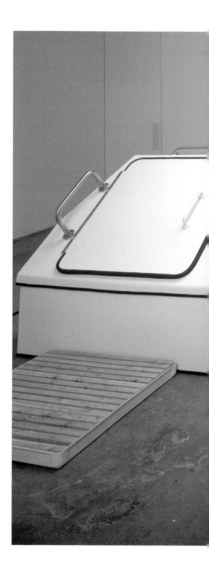

Fig. 14: Installation view of showers from _The El Niño Effect_, 1997/98.
Christopher Grimes Gallery, Santa Monica, 1998.

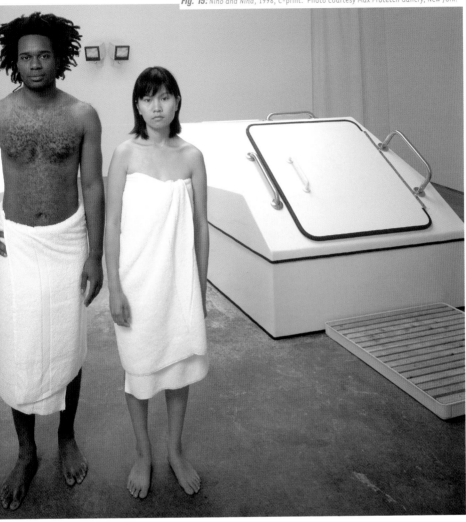

Fig. 15: *Niño and Niña*, 1998, C-print. Photo courtesy Max Protetch Gallery, New York.

Fig. 16: Installation view of *Windshear* from *The El Niño Effect*, 1997/98.
Christopher Grimes Gallery, Santa Monica, 1998.

39

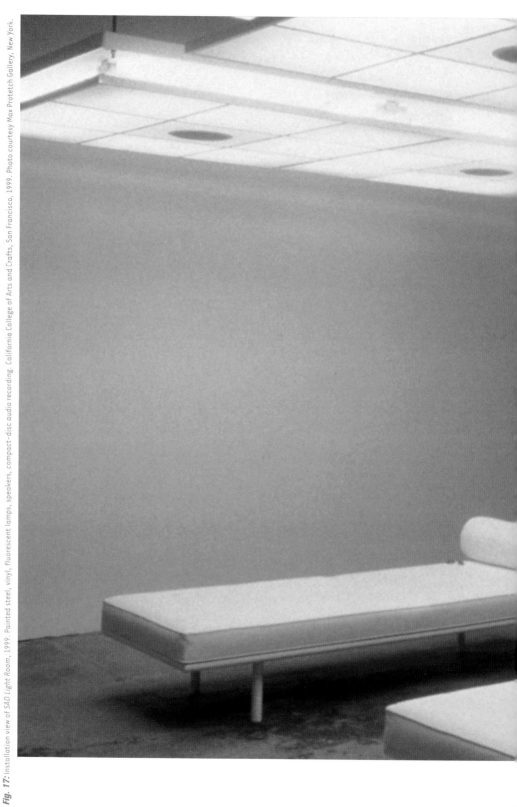

Fig. 17: Installation view of *SAD Light Room*, 1999. Painted steel, vinyl, fluorescent lamps, speakers, compact-disc audio recording. California College of Arts and Crafts, San Francisco, 1999. Photo courtesy Max Protetch Gallery, New York.

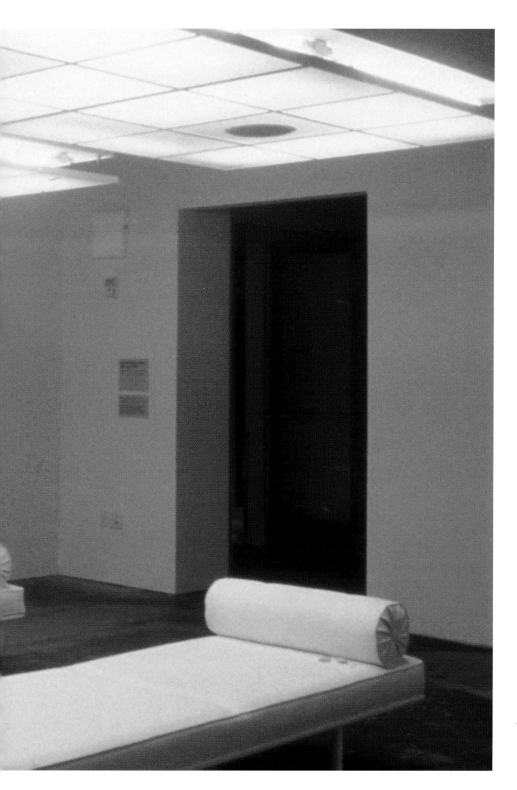

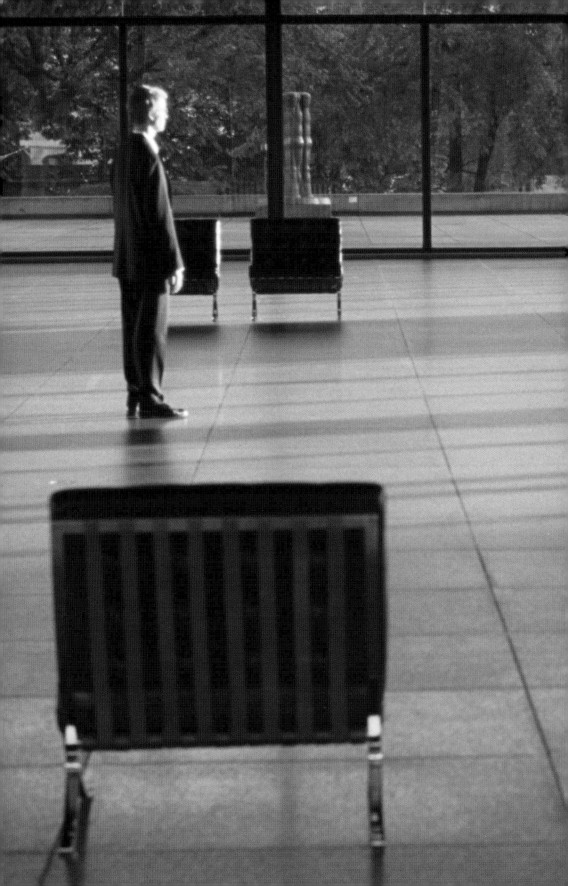

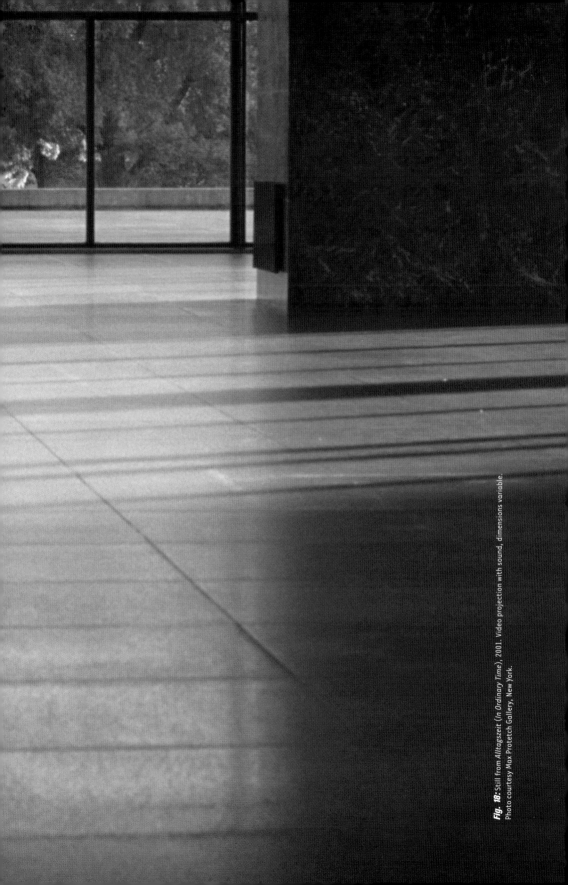

Fig. 18: Still from *Alltagszeit* (*In Ordinary Time*), 2001. Video projection with sound, dimensions variable. Photo courtesy Max Protetch Gallery, New York.

Fig. 19: Still from *Alltagszeit* (*In Ordinary Time*), 2001. Video projection with sound, dimensions variable. Photo courtesy Max Protetch Gallery, New York.

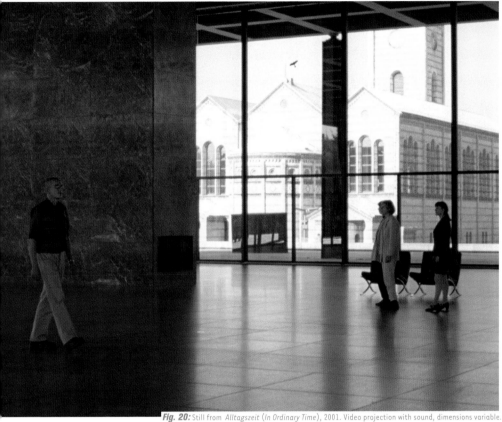

Fig. 20: Still from *Alltagszeit* (*In Ordinary Time*), 2001. Video projection with sound, dimensions variable.
Photo courtesy Max Protetch Gallery, New York.

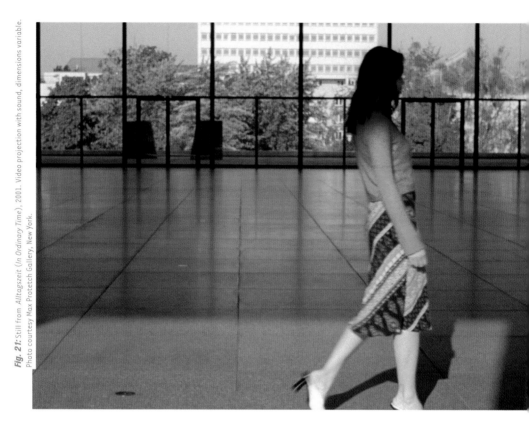

Fig. 21: Still from *Alltagszeit* (*In Ordinary Time*), 2001. Video projection with sound, dimensions variable. Photo courtesy Max Protetch Gallery, New York.

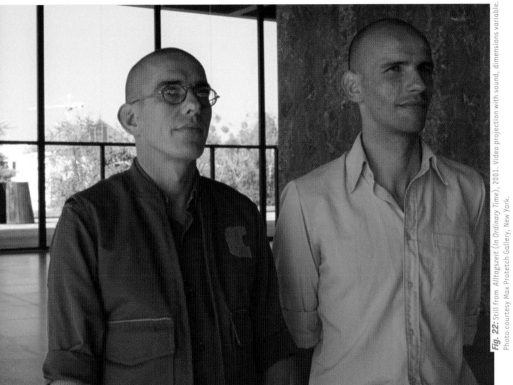

Fig. 22: Still from *Alltagszeit (In Ordinary Time)*, 2001. Video projection with sound, dimensions variable. Photo courtesy Max Protetch Gallery, New York.

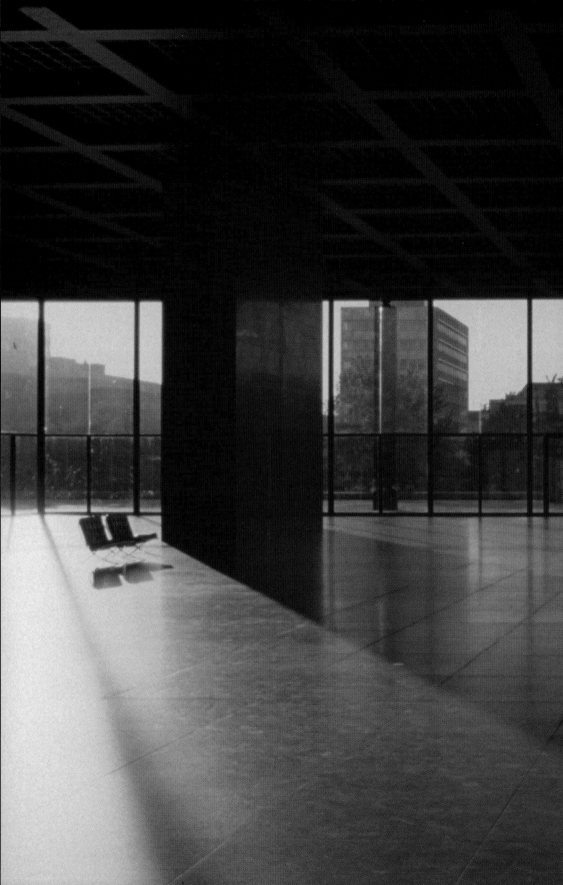

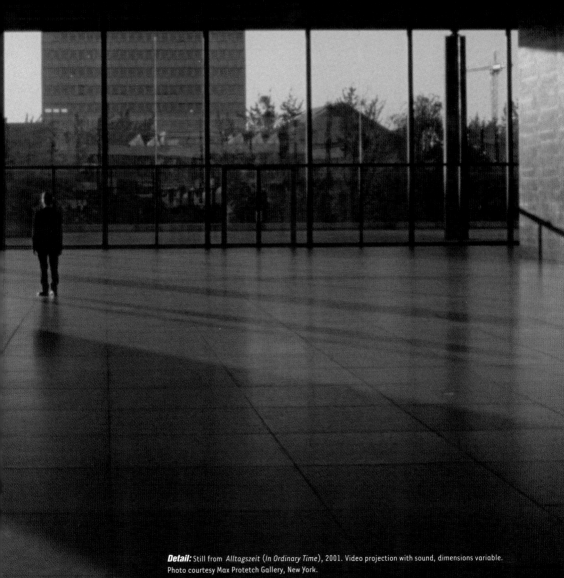

Detail: Still from *Alltagszeit* (*In Ordinary Time*), 2001. Video projection with sound, dimensions variable.
Photo courtesy Max Protetch Gallery, New York.

Fig. 23: Installation view of *The Garden of Delights*.
Southeastern Center for Contemporary Arts, Winston-Salem,
NC. 1998. Photo courtesy Max Protetch Gallery, New York.

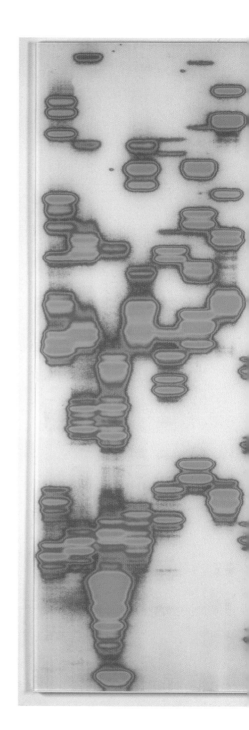

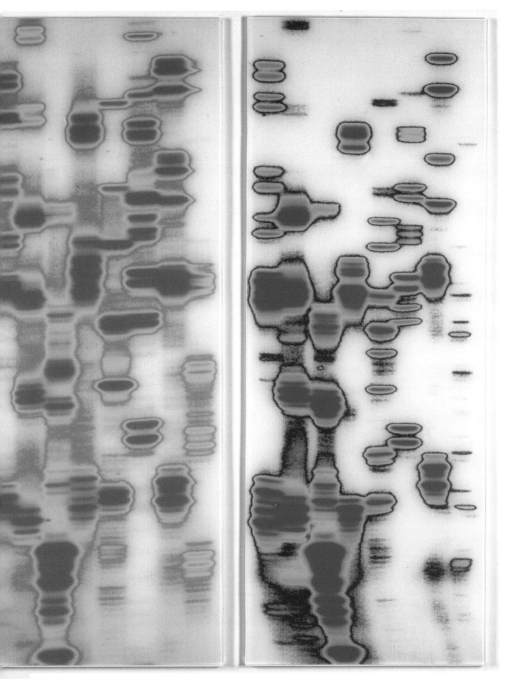

Fig. 24: *Iñigo, Elvi, and Iñigo* (from *The Garden of Delights*), 1998. Three chromogenic color prints. Overall 60" X 74". Collection Whitney Museum of American Art, New York; Purchase, with funds from the Photography Committee, 2000.101 a–c. Photo courtesy Max Protetch Gallery, New York.

NO-
WHERE
TO
HIDE

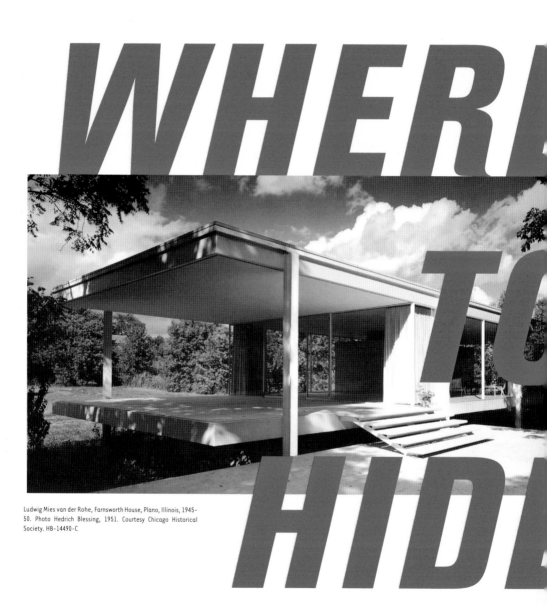

Ludwig Mies van der Rohe, Farnsworth House, Plano, Illinois, 1945-50. Photo Hedrich Blessing, 1951. Courtesy Chicago Historical Society. HB-14490-C

by Anna Novakov

Iñigo Manglano-Ovalle's recent installations are enigmatic, hybrid works of contemporary art that borrow operational strategies from mid-century modernist architecture and its cinematic counterpart, film noir. These three works, *Le Baiser/The Kiss*, 1999, *Climate*, 2000, and *Alltagszeit* (*In Ordinary Time*), 2001, incorporate some of Ludwig Mies van der Rohe's architectural masterworks with contemporary soundtracks and images that shift us firmly from the postwar period to the present.

Manglano-Ovalle is part of a group of young artists, including Italian photographer Luisa Lambri, who have picked up an interest in modernist architects and their oeuvre. Looking at the work of Le Corbusier (himself an artist turned architect), Mies, Adolf Loos, and others, they have explored not only their formal vocabulary but their spatial dynamics, with a particular emphasis on their innovative use of glass and transparency. An older generation of artists, such as Dennis Adams (notably with his 1995 House for Josephine Baker, based on the 1928 maquette by Adolf Loos)(Fig.25), Alfredo Jaar (himself trained as an architect), and Dan Graham (with his glass pavilions)(Fig.26), began looking in the 1980s at the vocabulary of modernist architecture for source materials and as a way of facilitating a distinct point of view. As these artists abandoned traditional galleries and museums for the openness of public spaces, they made sideways glances toward the work of modernist architects and utilized some of their strategies as ways of approaching their urban interventions. Manglano-Ovalle's work, although borrowing liberally from modernist tenets, is simultaneously quite contemporary. His most recent installations pry ideas of architectural space out of their 1950s and 1960s referents and bring them into our own *fin de siecle* period.

Le Baiser/The Kiss is a video installation filmed at the Farnsworth House, a modernist land-mark completed by Mies van der Rohe in 1951 for the physician Dr. Edith Farnsworth. The video shows the artist, dressed in a gray workman's jumpsuit and an orange cap, cleaning the windows of the house with a rag, yellow bucket of soapy water, and a long-handled squeegee. As he glides over the glass the squeegee makes a kind of "kissing" sound, hence lending the piece its title. Inside the glass house, seemingly oblivious, a female disk jockey is operating a turntable and mixing music. She is dressed rather androgynously in a red short-sleeved shirt and pants, her headphones apparently making her unaware of the window washer and the sounds emanating from his squeegee.

With *Le Baiser/The Kiss*, Manglano-Ovalle captures the magnificent natural setting of the Farnsworth House. Filmed in the fall, the video displays the changing colors of the surrounding trees and foliage. This vibrant natural palette is framed by the clarity of the floor to ceiling windows. Through the almost loving window washing we are reminded of the scale and transparency of the glass walls and how they frame the landscape as well as the lone occupant of the house.

Transparency reemerges as a theme for Manglano-Ovalle in *Climate*, a multi-channel video installation filmed on location inside the twin towers at 860-880 Lake Shore Drive on Chicago's water-front. In *Climate*, two men, dressed in suits, are wearing single-ear headphones with microphones, their other ears silenced by orange ear plugs. They are alert, looking out of the apartment windows, waiting for something to happen. Another man meticulously takes apart and cleans an automatic rifle. A woman sits in the lobby of the apartment building, waiting. A security guard is also positioned in the lobby, sitting at his desk. The glass lobby, which is panned repeatedly in *Climate*, resembles a sophisticated terrarium built to shelter as well as display its occupants.

Manglano-Ovalle's most recent work with Mies's architecture is set in the Neue Nationalgalerie in Berlin. The museum's temporary exhibition space, a classic Mies glass and steel pavilion, is the setting for *Alltagszeit* (*In Ordinary Time*). The interior of the gallery was filmed during the course of one day, sunrise to sunset. Through the massive glass windows, we witness the beauty of the cast shadows as the changing light floods the space with color. While devoid of art at the time, the gallery was neverthless populated by figures who appear throughout the all-day film. Combining time-lapse and real-time footage that was speeded and edited, *Alltagszeit* becomes condensed into a sixteen-minute piece. By doing this, the artist succeeded in creating a strange, ethereal world, populated by people that enter the space, perhaps linger, and then leave. The time compression causes their movements to appear jerky and nervous. In addition to the appearance of the strangers, we also are aware of the constant presence of a male figure who looks like a museum guard. He is a vigilant figure who contributes to the scene's overall tone of anxiety by pacing back and forth or standing still while nervously shifting his weight from foot to foot.

The sense of anxiety in *Alltagszeit* is further heightened by the addition of an ethereal, almost hypnotic musical score that relies heavily on repetition and slight gradations of sound. The soundtracks for *Alltagszeit,* as well as *Climate* and *Le Baiser/The Kiss*, add much to the emotional tone of the installations. All three works feature music composed by sound artist Jeremy Boyle. The soundtrack for *Climate* also includes a complex collection of recordings of global weather reports read in Korean, a children's lullaby, and financial information. The effectiveness of these sound-tracks relies heavily on habitual viewing responses that have conditioned us to associate such filmic devices as a sound score with a sense of anticipation. We wait and watch for something to happen, as do the men looking out of the Lake Shore Drive apartment windows, the woman sitting in the glass lobby, or the guard in the gallery.

Much of the anticipation associated with sound tracks is the result of viewing habits that evolved during the 1940s and 1950s and were epitomized by the film noir cinematic genre. Films of the period such as *Kiss of Death* (1947), *Night and the City* (1950), and *Dark Corner* (1946), fed off American postwar and Cold War paranoia. Alfred Hitchcock's popular thriller films of the 1950s and 1960s such as *Vertigo*, *Rear Window*, and *Psycho* also come to mind. We know from the opening scenes of these films that we are to expect drama and violence.

Manglano-Ovalle's installations, although not visually reminiscent of film noir, owe much to noir's anticipatory sensibility. In his work, as in these films, we hear the soundtrack and recognize it as an omen, a sign of things to come. This anticipatory state is further enhanced by the artist's exploration of visual transparency. We view the subjects of the videos with the aid of the windows that frame them. We see passing cars reflected through the windows of the lobby. Reflections bounce off the Mies glass table inside the apartment. The apartment windows, resembling movie screens, direct our gaze and turn on our cinematic reflexes. We wait and anticipate what we are so accustomed to seeing - action. (There is, of course, also a very direct use of architectural elements in film noir. Transparency is often directly referenced through the use of Venetian blinds and picture windows as repeated cinematic framing devices).

Mies had long dealt with the subtleties and gradations of architectural transparency. While working in Weimar Germany with long-time partner Lilly Reich, he created the Plate-Glass Hall. This 1927 installation, intended originally as an elaborate advertisement for the Association of German Plate-Glass Manufacturers in Cologne, turned out to be a significant, far-reaching prototype for the modern domestic space. The living and working spaces of the environment were separated and delineated only by a series of glass partitions. The inhabitants situated themselves in the structure by always having at least a partial view of the adjoining rooms and each other. The colors and textures of the glass walls varied from clear to etched, and olive-green to mouse-gray. The formal variations of the glass, along with variations in the color of the linoleum flooring, established the divisions between one space and another. The way that one navigated through the rooms was by being aware of the layers and subtleties of transparency framing each space.

For Manglano-Ovalle, transparency and sound act sympathetically on the senses. In this Mies "trilogy" the exhibited works evoke in the viewer a feeling of foreboding and suspense. The repeated use of headphones and earplugs, and the very deliberate manual ear plugging by the windowwasher in *Le Baiser/The Kiss* and the headphoned men in *Climate*, draw our attention to sound and hearing. However, unlike in *Psycho* and its cinematic predecessors, here there is no "shower scene," no dreadful final event. We are, after all, not looking at work created in the immediate post-war period, but rather at the end of the century—a time in which the culminating event has been replaced by a persistent sense of anxiety that is not directed at anything in particular.

For today's viewers, transparency reveals itself most commonly as a kind of surveillance fetish made manifest by Big Brother, an erasure of boundaries between public and private space. Of course, since the end of the Cold War, much interest in visual surveillance has moved away from watching the activities of the Soviet bloc toward an obsession with domestic espionage. Looking into someone else's "windows" has become something of a national as well as global preoccupation. We display a fascination with the complementary activities of looking out of our windows and looking into our neighbors' windows, whether directly or with the assistance of computer monitors, television screens or other prosthetic, digital technologies.

Manglano-Ovalle's recent work has, quite brilliantly, recognized and revealed the structures of anxiety evoked by modernist architecture and how those structures have been fed by filmic discourse which grew up alongside it. Doom has turned into a more generalized sense of dread. We no longer know what we fear, only that we fear it.

Ludwig Mies van der Rohe, 860-880 Lake Shore Drive Apartments, Chicago, 1948-51. Photo courtesy Balthazar Korab, 1966.

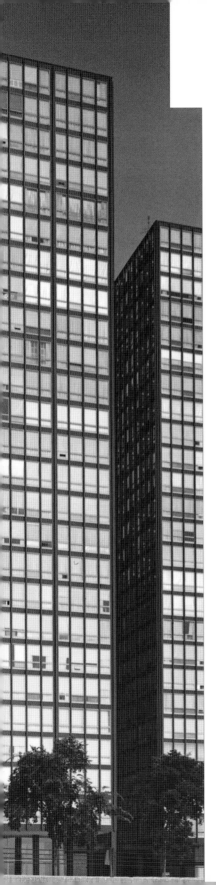

Farnsworth House
Plano, Illinois

Dr. Edith Farnsworth was in her early forties, working as a physician in a hospital in Chicago when she bought property in Plano, near the banks of the Fox River, in the first months of 1945. A short time later she met Mies van der Rohe, then 59, at a dinner party hosted by some mutual friends. He had been teaching in Chicago at the Illinois Institute of Technology (formerly the Armour Institute of Technology) after moving from Germany to the United States in 1938. She mentioned to him during the course of the evening that she had purchased this property and wanted to build a country retreat, a place to get away from her stressful professional practice in Chicago. Mies was immediately interested in the prospects of a commissioned private house and began work on the project shortly after their first encounter. For Mies, the Farnsworth House provided a much-needed showplace, a stage for the playing out of his innovative work. Farnsworth was an affluent client who would allow him to complete a home in the United States (his only one)—something he had wanted to do since his emigration from Germany. The project progressed slowly, with much conflict between client and architect. In 1947, a maquette of the house was exhibited (through the assistance of his protege Philip Johnson) at the Museum of Modern Art in New York. Finally in 1951, six years after that first conversation over dinner, the house was complete.

The house, much to Farnsworth's annoyance, ended up costing $74,000, almost twice the original estimate. (This substantial cost discrepancy led to a lawsuit by Mies and a countersuit by Farnsworth which was ultimately settled out of court.) But more importantly for our interests here, the house was hardly the refuge that she wanted. It was instead a glass box which, although providing her with a clear view of the surrounding landscape, also relentlessly framed her as the sole occupant of the house. ***There was nowhere to hide.*** She complained of "noses pressed again the glass" — architectural enthusiasts and curious onlookers who would drive to the house on weekends to take a look at it. She said the house was "transparent, like an X-Ray." However, even with her complaints, Farnsworth ended up living in the one-room glass house for twenty years before moving to Italy at the end of her life for some much-desired anonymity. (Farnsworth's relationship to the house is discussed extensively in Alice T. Friedman, *Women and the Making of the Modern House: A Social and Architectural History*, Harry N. Abrams Inc., 1998)

860-880 Lake Shore Drive Apartments
Chicago

The high-rise apartment towers on Lake Shore Drive were started by Mies in 1948 and completed in 1951, the same year as the Farnsworth House. The 860-880 towers represented, in addition to the pavilion form, the other tremendously significant aspect of Mies's work—the skyscraper—the glass tower. The client for the 26-story plate-glass towers was real estate mogul Herbert S. Greenwald. In 1956, five years after the completion of the towers, Mies added a glass pavilion on top of one of the apartment towers for Greenwald himself. The pavilion, invisible from the street level, provided stunning views of Chicago as well as a personal refuge for the developer. Greenwald lived there until his untimely death in 1959 in an airplane crash. His widow continued to live in the apartment well into the 1970s. The pavilion was so hidden from view, that its very existence came as a surprise to the tenants of the building. Greenwald's development firm, later called Metropolitan Structures, was responsible for several important construction projects such as Nuns' Island in Montreal; 111 East Wacker Drive, Chicago; Illinois Central Air Rights Project (later known as the Illinois Center); Highfield House; and One Charles Center in Baltimore.

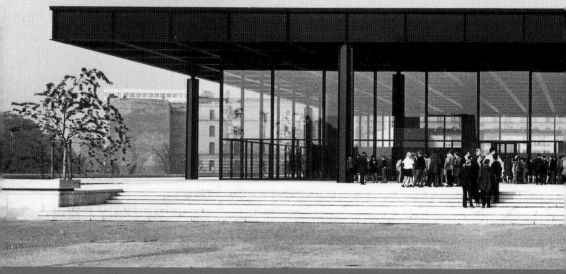

Ludwig Mies van der Rohe, Neue Nationalgalerie, Berlin, 1962-68. Photo courtesy Balthazar Korab 1968.

Fig. 25: Dennis Adams, *House for Josephine Baker*, 1995.

Fig. 26: Dan Graham, *Two-Way Mirror Cylinder Inside Cube*, part of the *Rooftop Urban Park Project*, 198? Long-term installation at Dia Center for the Arts, 548 West 22nd Street, New York. Courtesy Dia Center for

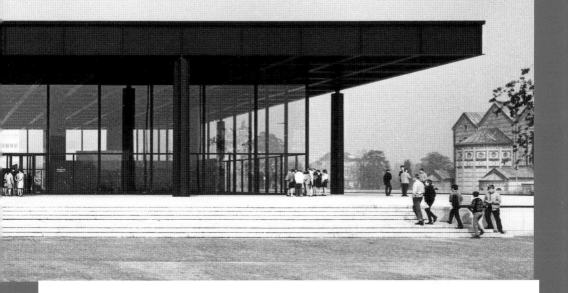

Neue Nationalgalerie
Berlin

In 1968, a year before his death at the age of 83 and 30 years after
he moved to the United States, Mies returned to Germany. He com-
pleted his last project, the Neue Nationalgalerie, a museum for
twentieth-century art set on Berlin's Potsdamer Strasse in the city's
Tiergarten district. The building houses an impressive collection of
modernist masterworks including much of the work of the expres-
sionist school , labeled "degenerate" during Hitler's reign of terror.
Mies's building is frequently compared to those of the German archi-
tect Hans Scharoun, who built several buildings in close proximity to
the museum, including the Philharmonie (completed in 1963),
Kammermusiksaal (begun in 1960 and completed 30 years later
under the architect Edgar Wisniewski) and the Staatsbibliotek
(1967-1978, also with Wisniewski). Scharoun's buildings surround
the Neue Nationalgalerie and form the Kulturforum or Berlin's arts
complex. Stylistically, they couldn't be more diverse. Scharoun
emerged out of a long-nurtured expressionist background. When he
was well into his 70s, he was finally able to create buildings which
were intended as symbolic manifestations of his longheld democrat-
ic and socialist ideology. The curving organic forms of his buildings
emphasize, through contrast, the clean openness and hard edges of
Mies's glass pavilion. The contrast apparent in this structural mirror-
ing is not dissimilar to the uneasy position occupied by Mies's
Barcelona pavilion, which is situated in the midst of highly ornate
and dominating orientalist buildings. The pavilion was constructed in
1929 as the German national pavilion for the Barcelona International
Exhibition. The pavilion was for Mies another collaborative project
with Lilly Reich who was instrumental in the interior color scheme of
the space. After the 1929 exhibition, it was dismantled only to be
reconstructed in 1986, some 57 years later.

IN-
TER-
VIEW

by Michael Rush

That goes back to the question of beauty, form, light, time, and sound, because my feeling is the off-the-street viewer should come in and have a phenomenological experience. I want them, in these architectural works that hang in space, to engage the image and recognize that their body is also part of the image and that it isn't a projection on the wall and therefore they aren't a neutral observer in a movie theater, a nameless observer occupying a nameless neutral coordinate from which to look at the screen or the box. They also are figures occupying space and they can move around or inside the installation, to the back of the projection, to the front of the projection. They become incorporated as bodies. Now, in order to motivate them to do this you have to present something that is visually compelling, which has a timeline that is also compelling in order for them to stay, and maybe ask themselves some very simple questions such as, "Which image should I be looking at?" or "Where should I be standing?" or "Should I be in here? Am I supposed to be here or there?" Those are critical questions in terms of the politics of space. This is observing space by occupying it with your body, not just on a retinal level. In the Berlin piece it's very much all about how the figure is able to impact onto the architecture, onto monumental space, as much as it is about attempting to hold those figures in time. They articulate the space and articulate the content for that space.

This leads me to the area of your relationship to Mies van de Rohe and how you've stepped very deeply inside his tracks in the past several years. Let me just start by asking about your intention of introducing the body so centrally into these geometrically pure spaces. What you are hoping to derive from doing that?

I think my project went through different stages. In a way it's not a study of Mies, it's kind of a use of Mies. I am using Mies as a stage, which becomes very clear in the Berlin work. But I think in Le Baiser/The Kiss the role of the body is very much that of problematizing both High Modernism and problematizing the role of contemporary artists within the ongoing discussion of Modernism. It's very much trying make the building mine and to provoke it with a kiss that squeaks at the same time, to wash these windows in an attempt to make the transparent more transparent. It's a ludicrous act. So in that

58

Q

How much do you like the viewer to know going in to see one of your installations, I mean the ordinary off-the-street viewer?

case it is the artist engaging that particular architecture, that particular architect, that particular moment both in irony and in homage. A place inbetween. The camera moves inside and outside because I think that my position is always moving inside and outside. I am outside this building because I am criticizing it. I am inside it because I am loving it. And so the camera moves from this inside/outside space, but not so much on a formal level. I mean that on an ideological plane also, I am inside and I am outside.

I am interested in the polarities in your work. You speak of inside and outside and there are clearly issues of public and private, sound and silence in the way you shoot and in the way you show your community concerns and also the isolation of some of the figures, almost all of the figures in your work. Can you talk to me about the opposites that you bring together?

I think that *Climate* is where it really starts to drive. Because architecture in this work is merely a backdrop, you never get a sense of this building, but it is probably the one in which I address how these buildings work on a social level and how this failed architecture actually continues to work. That is, in *Climate*, the isolated figure in a decontextualized context is a reflection less on an architecture of the sixties than on a continuation of Modernism into what has become our own current condition—a virtual globalism where individuals are sightless, contained in isolation and are in acts of communication without meeting.

So in *Climate* it was very important to set up a scenario where things are happening pretty much all at the same time in terms of how they present themselves in this very loose or non-existing narrative on synchronized screens, and by referring both to this omnipresent weather station and this building or interior as a backdrop. All the figures are, in a sense, interconnected through time and yet isolated, so there is this notion of coexisting but being isolated. That is a polarity in *Climate* that I am very interested in because it is something that I want to make problematic: What is our current state of being in a world where our quality of life is beginning to be measured by how we can transfer information, communication, industry, money, through ways in which we don't have to make a physical connection? How does it

happen that we are promoting a world without borders, without definition, in which things are best if they are totally fluid? And in this virtual, borderless world we seem to become more isolated, and isolation is something that happens by containment, by separation. So how do those things coexist? Should they coexist? Where are we going with that?

Knowing a little bit of your background of having grown up in the triangle, as you call it, of Madrid, Bogotá, and Chicago, and from a Spanish parentage, I wonder why you weren't more attracted to someone like Gaudi than Mies.

Although I love Gaudi, he is probably not an architect I would deal with. I was actually beginning to do work on Eero Saarinen before I started to do work on Mies and I wanted to approach Saarinen's architecture before I approached Mies. Now I am interested in investigating Alvar Aalto and most interested in Neimeyer in Brasilia, because the spaces they have created are more closely tied to my life and how I was brought up and my current existence. They are places that posit a kind Modernism, a kind of International style, a kind of universalism that doesn't quite function—just like my growing up was kind of dysfunctional, schizophrenic, because you could be in all these places all at the same time. I mean, I was ten years old before I realized that not everybody spoke English and Spanish. Or in our current existence, one can be local, one can be in Chicago, but at the same time be global. Those are things that I am interested in. So Modern architecture really drives the point home.

Mies is the one out of all these Modernist architects who I, as a political being, would be least aligned with, because he was always decontextualizing his work. Although he could attach himself to a particular site, it was very formal and the social never really revealed itself. His Barcelona Pavilion, for example, could occur in a particular time of politics for the German state and find itself in Barcelona and then he could propose a building that was very much like it for the Third Reich in Brussels that never got built. I mean he could make these propositions. He could take over the Bauhaus and negotiate with the Nazi regime about how to sustain it, remain independent of it, but still be inside it, and then he'd transplant himself to the United States to build essentially one of his Tugendhat houses out in Wyoming.

Here is an architect for whom social context is irrelevant and that sort of Modernist architecture is what we are living with now, but in non-physical space, in virtual space.

I want to talk about sound in your work. I'm interested in how you shoot without sound and yet in the finished product the sound element is extremely important. It strikes me in Le Baiser *you have this female character, a DJ, and she is preoccupied with jiving round in this space, very much in contrast to the pristine surroundings that she is in, and the ominous sound elements in* Climate, *or the extended gunshot noise that you've used in other work. Can you address the centrality of sound in your work?*

I said that I never record live sound but that is untrue. When I recorded *Le Baiser*, of course we had to synchronize the squeegee sound. It is totally central though I never think about it as live sound. And of course we had to record every bullet dropping onto the glass table in *Climate*. Those are the only live recordings. But I don't use sound in a kind of linear time-based way. To me sound is very much an extension of sculpture. It has physical form to me. It drives and also occupies space. I think of sound in that way but on these pieces I have been working with a young artist and composer by the name of Jeremy Boyle, who I first started working with when he was a student of mine and I was working on a work called *Sonambulo*. *Sonambulo* in Spanish refers to a sleepwalker. It also refers to a particular moment, maybe it is still current, in which I was a chronic insomniac.

At that point my wife had threatened to buy me New Age tapes that would lull me to sleep with birds or streams and what not, and I had an ongoing position of opposition to New Age culture. It has found its way into my work in a number of pieces but I always take a critical stance, even though the work provides massages, or sensory deprivation baths or a meditative space. *Sonambulo* was one of the first of those works and the way it started was with my saying, "No, don't get me a recording of brooks, I'll make my own recording." So I took a gunshot and worked with a musical engineer and mathematician at the University of

Illinois at Chicago whose field of expertise was Chaos theory and fractal equations. We took a simple gunshot and replicated it through a series of mathematical equations and sound engineering to become the 385,000 bullets that make up the sound of thunder, lightning, rain on the ground and so forth in the work. We had to work with fractal mathematics, because otherwise the rain drops would fall rhythmically and we wanted to create a sense of the arbitrary.

Ultimately in *Sonambulo* what you get is a tape of a summer rain storm that starts abruptly with a gunshot and runs for about eleven minutes before it retreats into the distance. It's a very meditative tape that relaxes you, and it's only when you go to the label and see what the single source of this sound is, that you understand that this New Age sort of escapism, this artificial environment, is actually based on the one thing that causes this escapism, this retreat from the real, from the social space, from the neighborhood.

I'd like to move to the issue of technology in your work. You've used so many materials in your work, not just electronic technologies but biochemical technology, engineering technology, and the use of technology always seems to be in the service of an idea for you. As pristine as the presentation of your work can be, there is often a techno-atmosphere. Perhaps you can address your relationship to technology.

There is a difference between medium and technology. I think my work refers to technology, but the fact that it has a technological source is irrelevant. I am more interested in the references to technology, whether it is in the music, a kind of techno-drive, or in the figures with headsets or using some kind of wireless communication. That to me is really important. I mean as an artist, I am very conscious that in terms of technology, everything that we are working with is actually becoming obsolete on a daily basis. So in terms of technology, my strategy is not to become a technologist, in the same way that in terms of general art, my strategy has been not to become a craftsman. I never want to master the medium or master the object in such a way that the mastery of it actually drives the work. I am actually interested only in using it, in blatantly using it, in prostituting whatever medium I have,

whether it is DNA, sensory deprivation tanks, ballistic gelatin, video, or 35mm film. The idea is going to tell me what medium is appropriate and the medium is going to be appropriate only because it's appropriate, not because it is the medium.

You're not, I take it, inching toward making movies?

No, no, no, because I am not a writer. I think you have to be a writer and I think all movie makers have to know how to tell a story and I can't tell a story. I can only say, "What if this happened?" I am really interested in a precise moment or condition and I think in that way I am still a sculptor. Sculpture for me is an object in space and it's a condition you create and the viewer has to move around it.

I wanted to ask you about the uncontrollable nature of weather and the interest you have in it in several of these works.

Climate is a culmination of a series of works in which weather is used as a metaphor for something that contains no ideology. I first started with the gunshot in *Sonambulo*; in *The El Niño Effect* it was a sensory deprivation spa that was in a sense using the El Niño Effect as a metaphor for politics in the Northern and Southern hemispheres. With a piece called *Windshear*, which is a time-lapse film shot at the Nogales border between the U.S. and Mexico during a windshear event, it was the movement of two systems contrary to each other at different elevations. So in the film you see clouds at a certain elevation going north, and clouds at another elevation going south, and we captured the most peaceful component of that because ultimately it is prophetic of some sort of calamity like a tornado or hurricane. We created a loop of these clouds playing across the border, moving without any sort of cognition of the politics that belie that line. The video played in an installation in which one was able to participate by floating in the sensory deprivation tank filled with saline water heated to body temperature. But in order to do that one had to first take a shower, to release some of their own body oils off of their skin. So you had to go from a cold raining weather system (the shower) to the hot body of water (the tank) which is actually what drives the El Niño Effect in reality. This is a mini replication of the climatological event which is the El Niño Effect.

Historically the El Niño Effect is what the Spaniards named this event when they first experienced it. El Niño refers to the infant, the Christ infant specifically, but this is a Christ infant that is hugely powerful and is crying and wailing, throwing a tantrum. For Americans, the El Niño Effect forgets that history and El Niño is this boy, probably a brown boy, moving across the border from South America, through Mexico and into the United States. Weather as a way to approach ideology and politics has always been something I am interested in.

It leads me to wonder, despite the silence in your work, of the importance of language in your work. The very name El Niño for people in the United States particularly represents the "other," something that they are fighting against.

Exactly, that is why it's called *The El Niño Effect* because it is an American word. That title is not Spanish, it's American/English, it's not even English, it is American/ English because it is part of an American vocabulary of fear. For me, when one is bilingual, one has fun playing around with the conditions of language, and so in *The Kiss* it refers to the squeegee, but it also refers to the 1970s rock band, and it also refers to the notion of a kiss and in French it is the kiss. *Le Baiser* pretty much only means the kiss. But in English it has all these other kind of references. *Climate*, just as a word, refers less to weather systems than to the condition of our lives and if I titled that work in Spanish I think it would only be weather, *El Tiempo*. *Alltagszeit* means the everyday but it has a connotation of the mundane in the everyday. So I try to be careful because titles are the first place you go in my work to get some information that isn't readily there otherwise.

May 11, 2001 Chicago, Illinois

IÑIGO MANGLANO-OVALLE

1961 -
Born in Madrid, Spain,
Lives in Chicago, Illinois

EDUCATION

1989 -
MFA (Sculpture)
The School of the Art Institute of Chicago, Chicago, IL
1983 -
BA (Art and Art History, Latin American and Spanish Literature)
Williams College, Williamstown, MA

AWARDS & FELLOWSHIPS

1997-2001 -
Media Arts Award, Wexner Center for the Arts,
Columbus, OH
1998-2000 -
Media Arts Residency, Henry Art Gallery,
University of Washington, Seattle, WA
1997 -
ArtPace Foundation International Artist Residency
Fellowship, San Antonio, TX
1995 -
National Endowment for the Arts
Visual Artist Fellowship
Orion Fellow, University of Victoria,
British Columbia, Canada
Great Cities Fellowship, College Urban Planning,
University of Illinois at Chicago, IL
1994 -
Neighborhood Arts Program Grant,
City of Chicago Department of Cultural Affairs, IL
1992 -
Illinios Arts Council Artists Fellowship Award

SOLO EXHIBITIONS (selected)

2001 -
Cranbrook Art Museum
Bloomfield Hills, MI.
2000 -
Banks in Pink and Blue, Henry Art Gallery,
University of Washington, Seattle.
Climate, Max Protetch Gallery, New York.
Clock, Wexner Center for the Arts, Columbus, OH.
Galeria Soledad Lorenzo, Madrid, Spain.
1999 -
Le Baiser/The Kiss, Institute of Visual Arts,
University of Wisconsin, Milwaukee, WI.
Sonambulo II (Blue) Semi-Permanent Site-Specific
Installation, The Art Institute of Chicago,
Chicago, IL.
1998 -
The El Niño Effect, Christopher Grimes Gallery,
Santa Monica, CA.
Garden of Delights, South Eastern Center for
Contemporary Arts, Winston-Salem, NC.
Iñigo Manglano-Ovalle, Max Protetch Gallery,
New York.
1997 -
Balsero, Museum of Contemporary Art, Chicago, IL.
The El Niño Effect, ArtPace Foundation for
Contemporary Art, San Antonio, TX.
Flora and Fauna, Rhona Hoffman Gallery, Chicago, IL.
Game of Jacks, Instituto Cultural Cabañas Museum,
Guadalajara, Mexico.
Woofer, Contemporary Arts Center, Cincinnati, OH.
Woofer, Galerie Froment & Putman, Paris, France.
1996 -
Bouquet (From the *Bloom* series), Real Art Ways,
Hartford, CT.
Iñigo Manglano-Ovalle, Andrea Rosen Gallery,
New York.
1995 -
Iñigo Manglano-Ovalle, Feigen, Inc., Chicago, IL.
1994 -
Balsero, Thomas Blackman Associates, Chicago, IL.
Torch, IMAGE Film and Video Center, Atlanta, GA.
1993 -
Cul-De-Sac: A Street-Level Video Installation,
Museum of Contemporary Art, Chicago, IL.
Tele-vecindario: A Street Level Video Block Party,
"Culture in Action: A Public Art Program by
Sculpture-Chicago," curated by Mary Jane Jacob
Chicago, IL.
1992 -
Aliens who....., New Langton Arts, San Francisco, CA.

GROUP EXHIBITIONS (Selected)

2001 -
Alltagszeit (In Ordinary Time),
video installation commissioned by the Canadian
Centre for Architecture, Monteal; traveling to the
Whitney Museum of American Art, New York;
Canadian Centre for Architecture; and the Museum of
Contemporary Art, Chicago.
Between Art and Architecture, Schindler House,
MAK Center for Art and Architecture, Los Angeles, CA.
Empathy, Pori Art Museum, Pori, Finland.
Hieronymus Bosch, Museum Boijmans van Beuningen
Rotterdam, The Netherlands.
Search, a site-specific project commissioned by
InSITE 2000, San Diego, CA and Tijuana, Mexico.
Presented by Installation Gallery, San Diego, CA and
Instituto Nacional de Bellas Artes, Mexico City, Mexico.
What's New: Recent Acquisitions in Photography,
Whitney Museum of American Art, New York.

2000 -
*Age of Influence: Reflections in the Mirror of American
Culture*, Museum of Contemporary Art, Chicago.
Biennial 2000, Whitney Museum of American Art,
New York.
Eiszeit (Ice Age), KunstMuseum, Bern, Switzerland.
Interventions, Milwaukee Art Museum, Milwaukee, WI.
Things We Don't Understand, Generali Foundation,
Vienna, Austria.
Ultra Baroque: Aspects of Post Latin American Art,
Museum of Contemporary Art, San Diego, CA.

1999 -
Amnesia, The Contemporary Arts Center, Cincinnati,
OH; Biblioteca Luis Angel Arango, Bogotá, Columbia
and The Bronx Museum of Fine Art, The Bronx, NY.
ARCO, International Artist Project Room, Madrid, Spain.
As Above, So Below: The Body's Equal Parts,
Fabric Workshop and Museum, Philadelphia, PA.

*Best of the Season: Selected Work from the 1998-99
Gallery Season*, Aldrich Museum of Art, Aldrich, CT.
Searchlight: Consciousness at the Millennium,
California College of Art and Crafts,
San Francisco, CA.

1998 -
XXIV Bienal Internacional de São Paulo,
São Paulo, Brazil.
Hip, Rocket Gallery, London.

1997 -
Recent Acquisitions, The Bohen Foundation,
New York, NY.

1996 -
Art in Chicago 1945-1995,
Museum of Contemporary Art, Chicago.
Human Technology, Revolution, Detroit, MI.

1994 -
Correspondences/Korrespondenzen, Berlinische
Galerie Museum für Moderne Kunst,
Berlin, Germany.
Latin American Art in Miami Collections,
Lowe Art Museum, University of Miami, FL.
Urban Masculinity, Real Art Ways, Hartford, CT.

1993 -
Mixed Messages: A Survey of Recent Chicago Art,
Forum Center for Contemporary Art,
St. Louis, MO.
Urban Masculinity, Longwood Arts Gallery,
The Bronx, NY.
The Year of the White Bear, organized by Guillermo
Gómez-Peña and Coco Fusco, Otis Gallery,
Los Angeles, CA.

1992 -
Tele-Mundo, Terrain Gallery, San Francisco, CA.
The Year of the White Bear, organized by Guillermo
Gómez-Peña and Coco Fusco,
Mexican Fine Arts Center and Museum, Chicago.

2001 -

Klein, Jennie. "inSITE 2000," *New Art Examiner* (April 2001): 26-31.

2000 -

Betsky, Aaron. "The New Boxters," *Architecture*, vol. 89, no. 7 (July 2000): 83-89.

Cone, Michele C. *Artnews*, vol. 99, no. 6 (June 2000).

Cotter, Holland. "Iñigo Manglano-Ovalle," *The New York Times,* April 21, 2000.

Cullen, Catherine. *Art Papers*, vol. 245, no 4 (July/August 2000): 39-40.

Ellison, Victoria. "Life Potential: Gallery or Laboratory?" *Seattle Weekly*, February 17, 2000.

Fredericksen, Eric. "Obscure Objects of Desire," *The Stranger*, Seattle, WA, January 27, 2000.

Gilson, Nancy. "Creative 'Clock' Installation Tells Timeless Truths," *The Columbus Dispatch,* January 2, 2000.

Kaplan, Cheryl. "Iñigo Manglano-Ovalle," *BOMB*, no. 72 (Summer 2000): 96-99.

Kimmelman, Michael. "A New Whitney Team Makes Its Biennial Pitch," *New York Times,* March 24, 2000.

Moreno, Gean. "Iñigo Manglano-Ovalle and the Politics of Pleasure," *New Art Examiner* (September 2000): 22-25, 46.

Pollack, Barbara. "The Genetic Esthetic," *Artnews*, vol. 99, no. 4 (April 2000): 134-136.

Quinones, Paul. *Flash Art*, vol. 33, no. 213 (Summer 2000): 113.

Rose, Cynthia. "'Banks in Pink and Blue': A New Look at DNA," *The Seattle Times,* January 21, 2000.

Rush, Michael. "Transparent Scenarios," *Art in America* (October 2000): 134-137.

1999 -

Arning, Bill. "São Paulo Bienal," *World Art*, issue 20 (January 1999): 72-74.

Sokoloff, Ana, "Manglano-Ovalle: The Poetics of Tolerance," *Art Nexus* (January 1999).

Vogel , Carol. "Surprises in Whitney's Biennial Selections," *New York Times*, December 8, 1999.

1998 -

Isé, Claudine. "Confinement and Solitude: Feeling the El Niño Effect," *Los Angeles Times,* May 1, 1998.

Sherlock, Maureen. "Moral Minimalism and Suburban Spectacle," *Art Papers* (May/June, 1998): 22-25.

1997 -

Clearwater, Bonnie. "Studio Visit," *Trans*, vol. 1, issues 3/4(1997).

Zamudio-Taylor, Victor. "Where is the Bleeding Heart?" *Atlantica*, Gran Palma, Spain, no. 15 (Spring 1997): 82-91.

1996 -

Birbragher, Francine. *Art Nexus*, no. 22 (December 1996): 130-131.

Hakanson Colby, Joy. "We can Humanize Technology..." *Detroit News*, April 11, 1996.

Killam, Brad. "Iñigo Manglano-Ovalle at Feigen, Inc.," *Art Muscle*, vol. 10, no. 4 (April/May 1996): 34.

Palmer, Laurie. *Frieze* 27 (March-April 1996): 71.

Zamudio-Taylor, Victor. *Art Nexus*, no. 22 (December 1996): 152-154.

1995 -

Cantor, Judy. "Collective Experience," *New Times*, Miami, January 26, 1995.

Heartney, Eleanor. "Public Art in Action," *Art in America* (June 1995): 33.

Helguera, Pablo, "La Intrusión de la technologia en el ser," *Exito!* December 28, 1995.

1994 -

Corrin, Lisa. "Culture is Action: Action is Chicago," *Sculpture*, vol. 13, no. 2 (March-April, 1994): 30

Kirshner, Judith Russi. "Street-Level Video Block Party," *Artforum* (January 1994): 86.

Snodgrass, Susan. "Balero," *Art in America* (September 1994): 9.

1993 -

Cameron, Dan. "Culture in Action," *Flash Art*, vol. 26, no. 173 (November/December 1993).

Gamble, Allison. "Reframing a Movement," *New Art Examiner*, vol. 21, no. 5 (December 1993): 18.

Heartney, Eleanor. "Culture in Action at Various Sites," *Art in America* (November 1993): 136-137.

Kimmelman, Michael. "Of Candy Bars and Public Art," *New York Times*, September 26, 1993.

Muschamp, Herbert. "Design vs. Environment: Architects Debate," *New York Times,* June 23, 1993.

Pincus, Robert L. "Substantial Slapstick," *The San Diego Union-Tribune*, September 19, 1993.

1992 -

Gomez-Peña, Guillermo. "New World (B)order," *High Performance*, no. 58/59 (Summer/Fall 1992):60.

Hixson, Kathryn. "In the Heart of the Country," *ARTS Magazine* (September 1991): 89.

CATALOGUES

2001 -
Iñigo Manglano-Ovalle
Bloomfield Hills, MI: Cranbrook Art Museum.
2000 -
Biennial Exhibition, New York:
Whitney Museum of American Art.
Iñigo Manglano-Ovalle, Madrid:
Galeria Soledad Lorenzo.
Ultra Baroque: Aspects of Post Latin American Art,
San Diego: Museum of Contemporary Art, San Diego.
Things We Don't Understand, Vienna:
Generali Foundation.
Bienal Internacional de São Paulo, São Paulo
1998 -
Iñigo Manglano-Ovalle: The Garden of Delights, edited
by Sheila Schwartz, Winston-Salem: South Eastern
Center for Contemporary Art.
1997 -
Iñigo Manglano-Ovalle 97.4. San Antonio: ArtPace,
Foundation for Contemporary Art.
1996 -
Art in Chicago 1945-1995, Chicago:
Museum of Contemporary Art.
1995 -
Culture in Action, Seattle: Bay Press Inc.

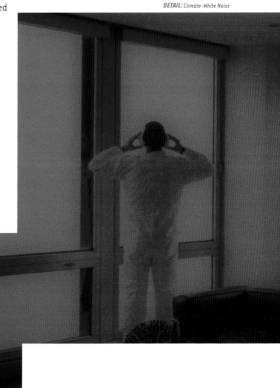

DETAIL: Climate-White Noise

Le Baiser/The Kiss, 1999
Video installation
LCD projector, laser disc player, speakers,
aluminum channel structure
Collection Museum of Contemporary Art,
Chicago, Sara Lee Corporation Purchase Fund.
Courtesy Max Protetch Gallery, New York.

Actors
Iñigo Manglano-Ovalle
Liena Damon
Videographer/Editor
Allan Siegel
Music
Jeremy Boyle
Technical Assistant
Kirsten Stoltmann
Sound Technician
Paul Dickinson

Climate, 2000
Video installation
LCD projectors, DVD players, "Secret Sound"
speakers, screens, aluminum channel structure
Collection The Bohen Foundation, New York.
Courtesy Max Protetch Gallery, New York.

Actors
Hamza Walker
Douglas Grew
Sonya Shah
Voices
Bora Kim
Barbara Holbert
Videographer/Editor
Allan Siegel
Music
Jeremy Boyle
Text Contribution
Jane M. Saks
Sound Technician
Paul Dickinson
Technical Assistants
Kirsten Stoltmann
Mike Davis

Alltagszeit (In Ordinary Time), 2001
Video installation
LCD Projector, Laser Disc player, speakers
Commissioned by the Canadian Centre for
Architecture, Montreal with generous support
provided by Elise Jaffe and Jeffrey Brown.

Artist/Director/Producer
Iñigo Manglano-Ovalle
Director of Photography/Editor
Allan Siegel
Sound Composer
Jeremy Boyle
Assistant Producer
Barbara Holbert
Assistant Camera/Production Assistant
Fleeta Siegel
Assistant Camera
Ingo Kratisch
Location Manager
Jutta Sartory
Production Assistant
Cheyenne Chew

Actors
Robert Abts
Konstanze Binder
Cheyenne Chew
Jakob Diehl
Christa Donner
Baerbel Freund
Barbara Holbert
Irina Hoppe
Arne Ihm
Doris E. Kahn
Ingo Kratisch
Magdalena Scharf
Fleeta Siegel
Mark Simon with Lucas

Climate-White Noise, 2000
Photograph laminated to Plexiglas,
two pegs, two noise protectors
Courtesy Max Protetch Gallery, New York.

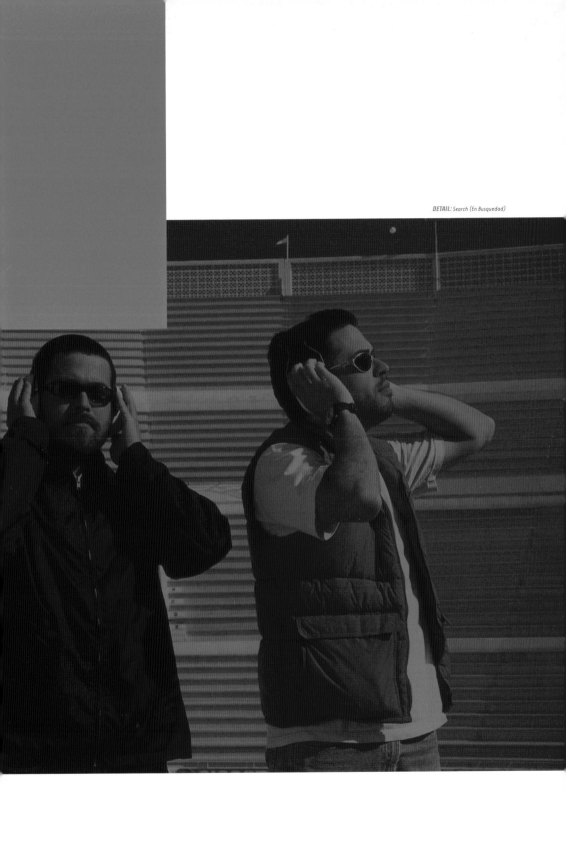

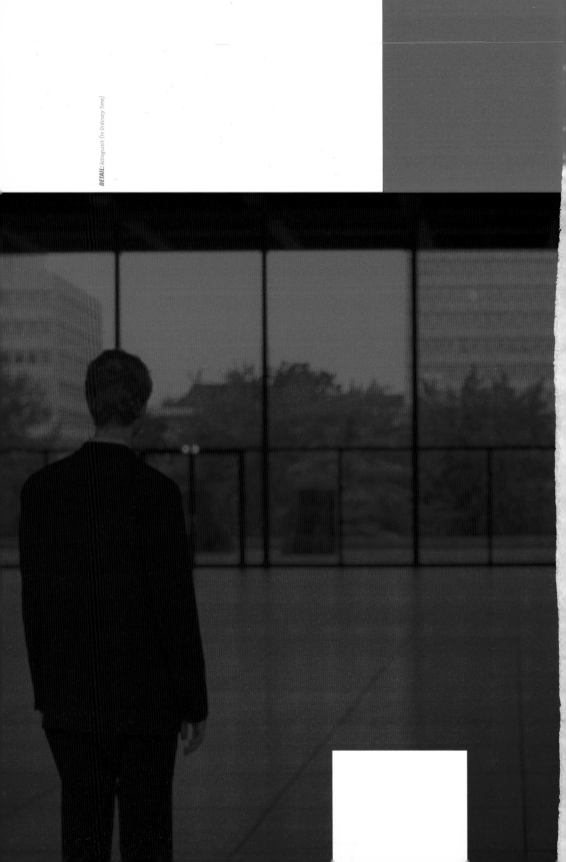